ANYONE CAN PAINT

WATERCOLOUR
FLOWERS

Previously published in 2018 as
The Paint Pad Artist: Watercolour Flowers

This edition published in 2024
Search Press Limited
Wellwood, North Farm Road,
Tunbridge Wells, Kent TN2 3DR

Text copyright © Julie King 2018, 2024

Photographs by Roddy Paine Photographic Studios

Photographs and design copyright ©
Search Press Limited 2018, 2024

ISBN: 978-1-80092-151-1
ebook ISBN: 978-1-80093-134-3

Suppliers
If you have any difficulty obtaining any of the materials and
equipment mentioned in this book, please visit the Search Press
website: www.searchpress.com

Bookmarked Hub
Extra copies of the outlines are also available to download free
from the Bookmarked Hub. Search for this book by title or
ISBN: the files can be found under 'Book Extras'. Membership
of the Bookmarked online community is free:
www.bookmarkedhub.com

You are invited to visit the author's website:
www.juliehking.co.uk

Dedication

I dedicate this book to my grandchildren, Lily, Alexander
and Freyja Hull, with love.

A flower that blooms
Gives joy to others.
It lifts us up and fills us with colour.
Life is a canvas,
Which is going to grow.
Take control of the brush
And let your love flow.

Acknowledgements

With grateful thanks to my editor, Edward Ralph,
and photographers Roddy Paine and Gavin Sawyer.

ANYONE CAN PAINT

WATERCOLOUR
FLOWERS

6 EASY STEP-BY-STEP PROJECTS
TO GET YOU STARTED

Julie King

SEARCH PRESS

CONTENTS

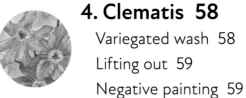

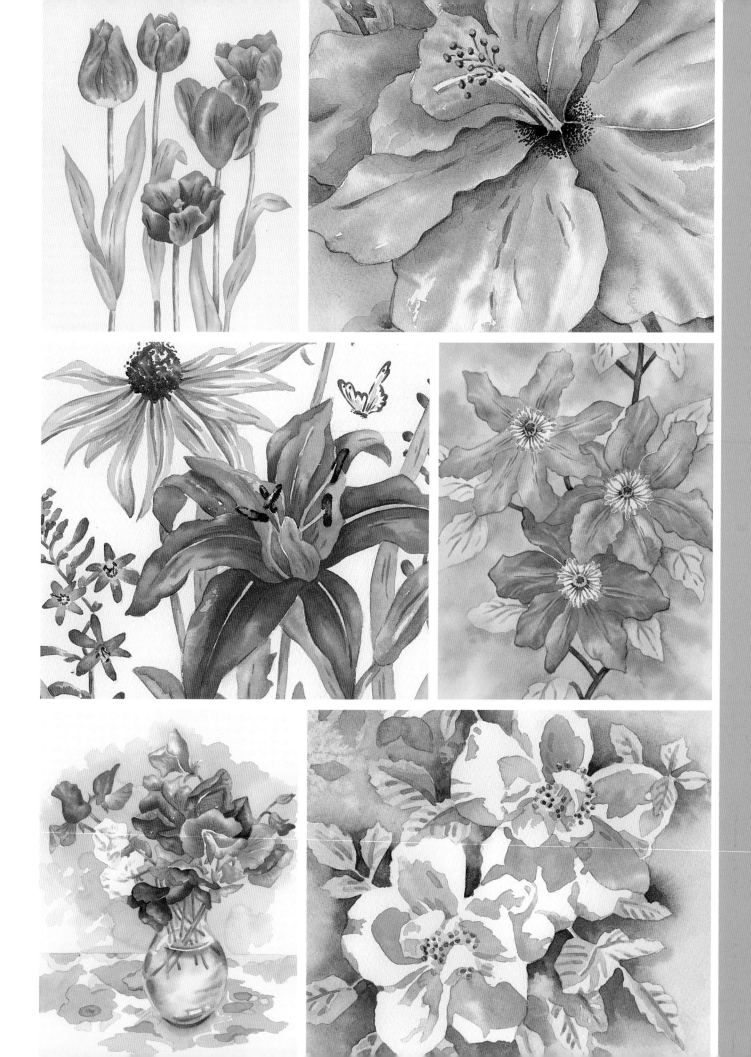

INTRODUCTION

Flowers have always played an important part in my life. I find their shapes, colours and textures fascinating. Whether growing in the garden or displayed in a vase, they are irresistible and uplifting; and to this day inspire me to fill many a paint pad with floral studies.

Watercolour is my favoured medium. Due to its transparency and luminosity, it is perfect for rendering the beauty and fragility of flowers and for capturing their wonderful and varied colours. Writing this book, all about painting watercolour flowers, gives me the opportunity to share my passions while introducing you to a rewarding and creative pastime. If you have always wanted to paint or to further develop your skills, now is the time!

Julie's top tips

'Life is enriched by variety, experiences and knowledge.'

Everything I learned as a printed textile designer and colourist has proven valuable in developing my expertise in painting and teaching.

Throughout this book you will find my Top Tips in boxes like this, which will give you useful hints that cover my working methods, techniques, colour mixes and the solutions to questions that I am often asked by my students.

Take time with the projects and be prepared to re-read sections to enable you to produce successful flower paintings. With lots of practice, I hope you will learn a lot from my book and develop a love of watercolour that inspires you to create your own paintings.

I have prepared six floral projects, all varied in colour, composition and style, making it easy for you to start out on your painting journey. Starting simply, each project highlights a selection of techniques and skills, and increases in complexity to gradually build your skills and help you practise. Each project is accompanied with an outline at the back of this book, all ready for you to trace and transfer onto your watercolour paper.

With a minimal amount of material, I will guide you through each painting project with easy to follow step-by-step instructions on the techniques, advice on which colours to use and how to mix them plus more. I hope you enjoy working through this book as much as I did preparing it.

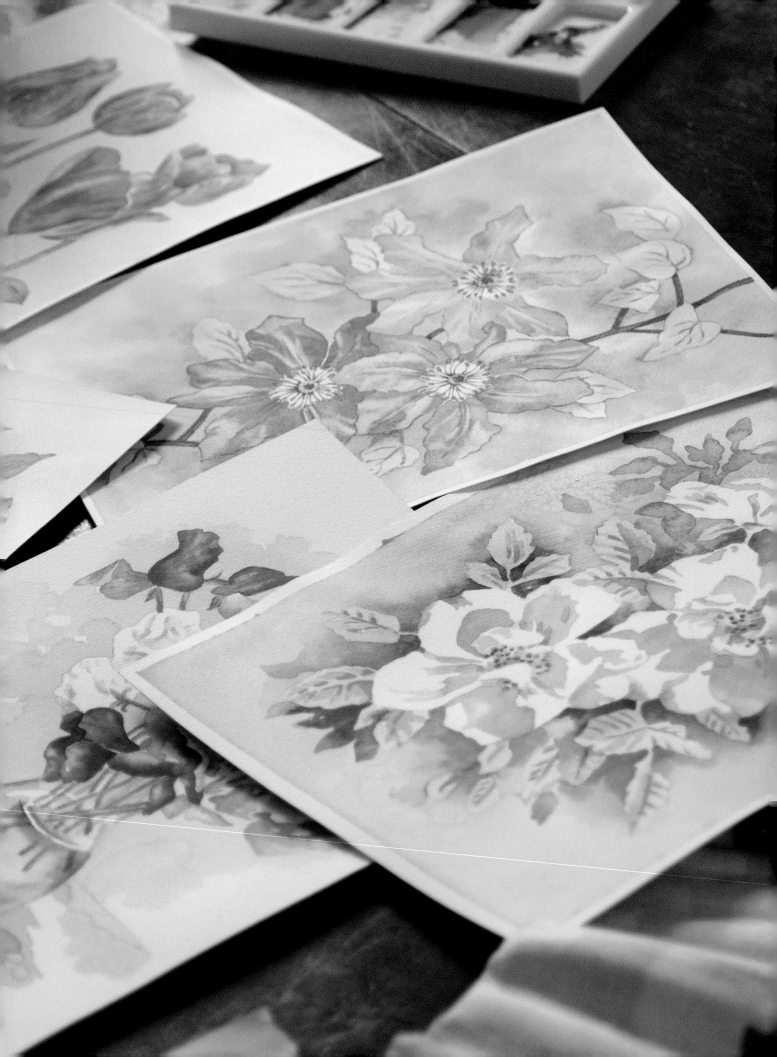

HOW TO USE THIS BOOK

HOW TO USE THE OUTLINES

The outlines at the back of the book are for you to trace. Feel free to make photocopies of the outlines for your personal use. This will allow you to try the projects again and again, to practise your skills and try out different combinations of colours.

Extra copies of the outlines are also available to download free from the Bookmarked Hub: www.bookmarkedhub.com – see page 2.

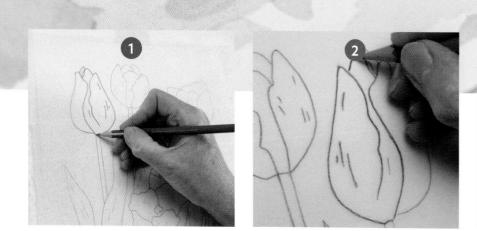

1 Lay a sheet of tracing paper over the outline. Secure it in place with a piece of masking tape. Use a relatively hard pencil, such as an HB or B, to trace over the outline.

2 Detach the tracing paper and turn it face down onto a spare piece of cartridge paper. Use a softer 2B pencil to go over the lines once more on the side now facing up.

3 Turn the tracing over once more and secure it onto a clean new piece of watercolour paper. Using a harder pencil (e.g. HB) with a good point, draw over the lines to transfer the image to the watercolour paper.

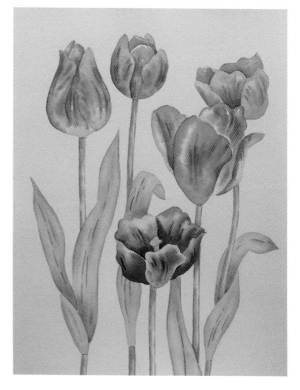

Project 1: *Tulips*, pages 20–31.

SETTING UP YOUR BOARD

It's important to feel comfortable when painting. I like to attach my paper to a lightweight drawing board to give a firm surface on which to work. Other surface options that you might like to try include a piece of hardboard, acrylic or even a plastic tray.
I find it best to have the board tilted slightly, as this also assists with the flow of paint.

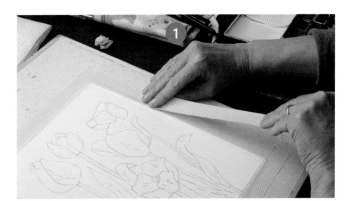

1 Secure your outline to the board. If you are adding a background wash to the painting, securing it on all sides with masking tape will help to hold the paper in place and reduce any risk of buckling.

2 Rest the board so that it sits at a thirty-degree angle. This is the ideal position to work; it lets the paint flow without forming drips and running out of control, and also creates a comfortable angle at which to paint.

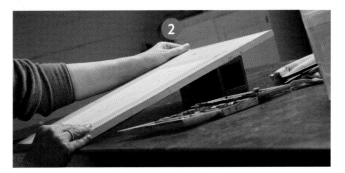

PREPARING TO PAINT

Before you begin, I suggest you read through the introductory pages of this book and decide which project you would like to start on. Beginner or not, I would advise you to commence with the first project, which is the easiest, and progress through the book. In this way, you will gradually develop your skills and pick up new techniques as the projects become more complex.

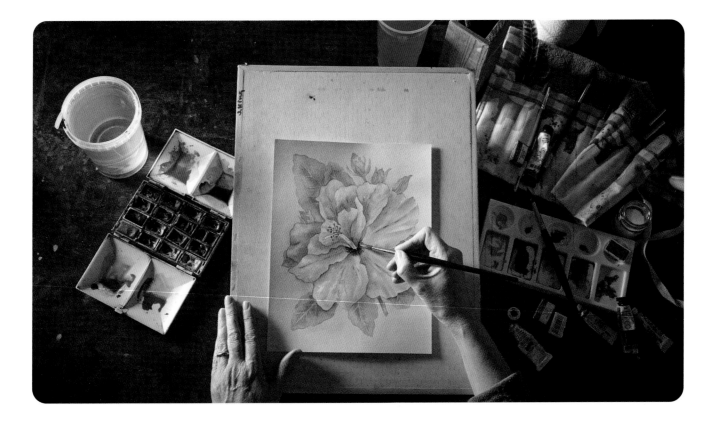

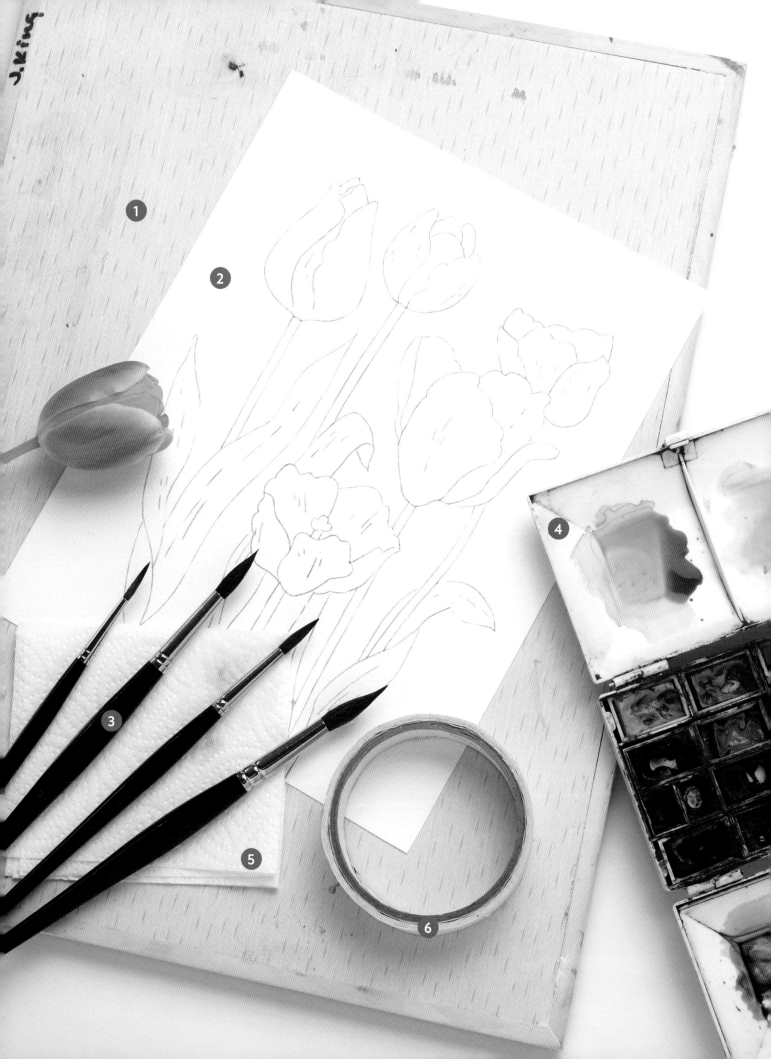

WHAT YOU NEED

The beauty of watercolour painting is that you don't need lots of equipment and materials to get started. Along with the book itself, the photograph below shows everything you need to paint watercolour flowers.

1 Drawing board

I favour a lightweight drawing board because it is so portable and light. It fits easily into my art bag and I can use it both indoors and outdoors. My board measures 33 x 43cm (13 x 17in), which is perfect for providing a support for the size of paintings included in this book. It leaves enough space around the edge to attach a border of masking tape if required.

2 Outline

The outlines for each of my projects are provided at the back of this book. If you wish to make copies of the outlines (see page 8), ensure that you transfer them onto good-quality watercolour paper, such as 300gsm (140lb) weight Not paper.

3 Brushes

Paintbrushes are available in a number of different shapes and sizes. I use mainly round (as opposed to flat) brushes as they are ideal for flower painting: the belly of the brush holds the paint when applying washes, and the point is perfect for detail.

Similarly, I use a selection of different sizes depending on the area I am painting. The smallest brush shown in the picture is a size 4, which is ideal for fine details like veins and flower centres, for example. The sizes 6 and 8 are medium-sized good all-rounders, and the largest brush is a size 10, which is perfect for larger areas such as wash backgrounds.

4 Paints and mixing palette

I favour solid blocks of compressed colour, known as pans, organized in a box with a lid which provides a good mixing palette. You will need a similar box of watercolour paints or, alternatively, a set of tubes of paint. Students' quality paints are adequate to start with, before progressing to Artists' quality once you are more confident.

I use pans when working on smaller paintings, but tubes of paint for larger paintings or while painting outdoors. A separate plastic mixing palette is required when using tubes. A plate or plastic lid can be a useful alternative.

5 Kitchen paper

This has many uses. When painting I often lean my hand on a folded sheet of kitchen paper, in order to protect the paper from any grease from my hands. It is also useful for absorbing excess water or paint from my brush, and when dampened I use it to clean my palette.

6 Masking tape

A low-tack masking tape is ideal for securing the watercolour paper to the drawing board. When it is secured along each edge of the paper it also provides a neat border to which the paint can flow.

Useful extras (not pictured)

- Two water pots: one for rinsing brushes, the other for wetting the paper when working wet-in-wet.

If you wish to trace the outline to practise your painting techniques or repaint the project (see page 8) the selection below will be required:

- HB or B pencil, plus a softer one such as a 2B
- Pencil sharpener

- Eraser
- Tracing paper – a small pad can be purchased, but as an economical and convenient alternative, you can use greaseproof paper
- Masking fluid: This is a latex solution, which can be applied to paper to form a resist against washes of paint. It then rubs off to reveal clean white paper when the paint is dry. I like to use Pebeo drawing gum.

GENERAL TECHNIQUES

PREPARING YOUR PAINT

In order to start painting, it is a good idea to practise mixing a pool of colour. The strength or tone of a colour depends on the amount of water added to the paint. The more water you add to the paint, the paler it will become, creating a tint. The creamier or thicker the consistency is, the stronger the tone of colour will be. The success of watercolour is very dependent on the consistency of the paint and the wetness of the surface of the paper.

1 Dip your brush into the water, to thoroughly soak the whole of the bristles. Tap off excess water on the side of the water pot. The brush should be wet, not dripping.

2 Sweep the bristles over the pan of paint – in this instance, quinacridone magenta – two or three times, until the paint softens. You will see the brush picking up some of the moistened paint.

3 Transfer the paint into the well by sweeping the brush into it. Pick up paint from the pan and deposit it into the well repeatedly to build up a sufficient amount of creamy paint.

4 To dilute the paint, dip the brush back into the water and give it a swirl.

5 Without tapping off the excess water, go back into the well of creamy paint and deposit the water. Repeat this to dilute the paint to the required consistency.

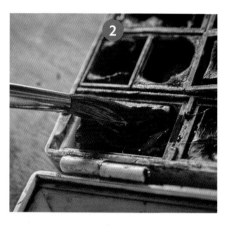

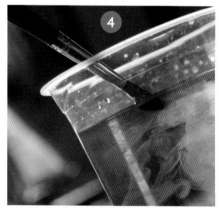

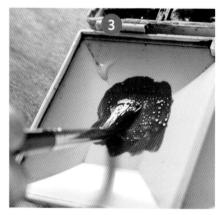

Julie's top tips

The only reliable way to test the consistency of paint is to paint a little on a spare piece of watercolour paper (or the back of one of the outlines) – ideally the same kind as you will be painting your finished piece on. As you can see here, the colour in the well does not necessarily look the same when it is applied to the paper.

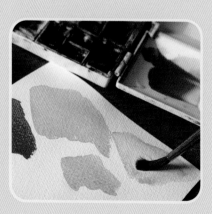

LOADING THE BRUSH AND APPLYING THE PAINT

The size of brushstrokes can vary, not just with the size of brush but also the amount of pressure you apply when holding the brush. Familiarize yourself with using different sized brushes to make marks on a spare piece of practice paper. When dampened well in water, a good brush will absorb and hold plenty of paint and will produce a fluid brushstroke.

1 Dip your brush and tap off excess water before you begin. This helps the brush to absorb the colour from the well. Put the bristles into the well, and move the brush gently around to encourage it to pick up the prepared paint. Roll the brush around a little to make sure that it is entirely covered. The paint will be absorbed into the whole of the brush, which will allow you to make a variety of marks.

2 The mark your brush will make on your paper will depend on the pressure you apply as you draw it along. Gradually pressing down and applying pressure will gently flatten the brush and result in broader strokes. The size of the initial line will depend on the size of the brush.

3 Lifting off and reducing the pressure will allow the shape of the brush to re-form into a point, resulting in a finer line.

4 Spend some time playing around with your paints, getting familiar with the marks you can make with your brush.

CLEANING YOUR BRUSHES AND PALETTE

It's always a good idea to have two pots of clean water so that your brushes can be rinsed out really well. These pots will need to be refreshed during a project rather than waiting until the end. Clean your palette regularly, so that the paint remains fresh when you mix new wells of colour.

1 Dip your dirty brush into your water and swirl it repeatedly.

2 Tap off excess water and repeat until the brush is clean.

Use a dampened piece of kitchen paper to clean your palette.

COLOUR RELATIONSHIPS

It's a good idea to have a little knowledge of basic colour theory. It really assists when mixing colour and makes painting fun. You can then prepare your own shades of colour rather than using ready-mixed paints.

All colours can be described as cool or warm and each primary colour has a warm and cool variation. Warm shades come forward in a painting and cool colours recede.

When painting an orange flower I would start with a hot red such as scarlet lake, and mix it with yellow. If I was painting a purple flower I would substitute the hot red for a cool one such as permanent rose, as this has more blue in the pigment, which will result in a fresher mix when combined with blue. I have therefore divided the top red segment of the colour wheel (below) into a cool and warm shade of red.

Choosing a colour palette

Considering the colour palette you are going to use before starting a painting allows you to use colours to unify the visual effect. This colour wheel shows the three primary colours (red, yellow and blue) placed equidistantly. Looking at the wheel, you will notice that the warm colours (red, orange and yellow) are on one side of the circle while the cooler shades (green through to blue and purple) are on the opposite side. When choosing a background to a flower, I will choose either a shade which harmonizes or one which complements:

- Colours adjacent to each other on the colour wheel are referred to as harmonious, as they work calmly together.
- Complementary colours are those opposite each other on the colour wheel. They are contrasting shades, which adds vibrancy to a painting.

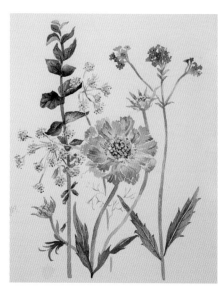

For this painting I selected three plants in cool shades which harmonized in colour: blue, mauve and pink-mauve.

The green leaves and stems harmonized too, but by adding a little yellow – the complementary of mauve – the painting became visually alive.

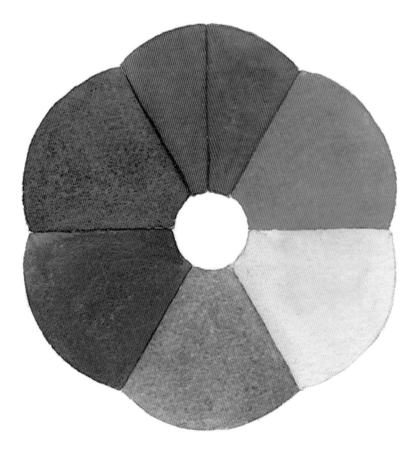

PRIMARY COLOURS

The primary colours of paint: red, yellow and blue. I used scarlet lake, transparent yellow and ultramarine blue.

WARM AND COOL COLOURS

Warm primaries: scarlet lake, transparent yellow and ultramarine blue.

Cool primaries: permanent rose, cadmium yellow pale and Winsor blue (green shade).

HOW TO PREPARE A COLOUR MIX IN YOUR PALETTE

Mixing colours in the well will give you a consistent colour, which is useful for specific colours that need to be used across the painting.

1 Starting with the colour that you want to be dominant in the resulting mix (transparent yellow here), place a little of the paint in one side of the well, as described on page 12.

2 Rinse your brush well, then pick up the next colour (scarlet lake here), and place it on the other side of the well.

3 Gradually stir the colours together, mixing them thoroughly.

4 The mix can now be used.

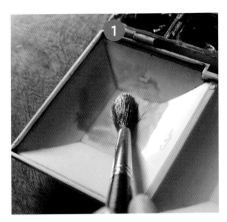
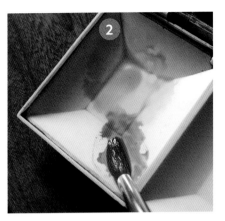
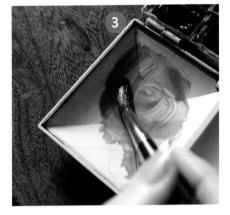
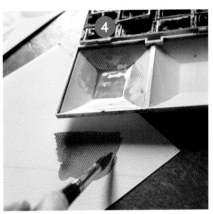

HOW TO MIX COLOURS ON THE PAPER

Allowing pure colours to mix on the paper will give a more vibrant effect. It is more spontaneous than pre-mixing colours in the well, and will sometimes give unplanned effects.

1 Prepare your pure colours (in this example, transparent yellow and scarlet lake).

2 Apply the first colour to the paper, then rinse your brush.

3 Dab off the excess water onto kitchen paper to ensure that your brush is clean.

4 Pick up the second colour and apply it nearby, drawing the colour into the initial wet base colour. Be direct with your brush. Avoid stirring the colour around too much, or you will lose the interesting effect.

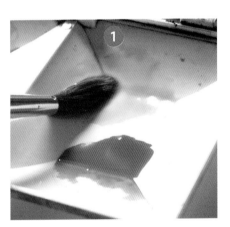

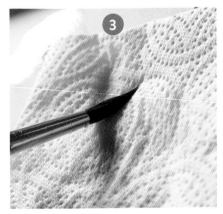
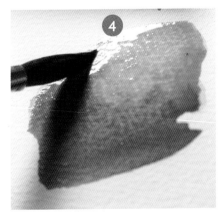

USEFUL MIXES

Secondary colours

The three secondary colours are orange, green and purple. They can be mixed by combining a primary colour with an equal quantity of the one next to it on the colour wheel, as shown to the right. Mixing different proportions of the primary colours can make many different shades of each secondary colour.

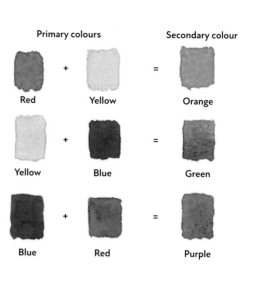

Primary colours			Secondary colour
Red	+	Yellow	= Orange
Yellow	+	Blue	= Green
Blue	+	Red	= Purple

Complementary colours

Not only do complementary colours work well together visually, they also have the ability to neutralize each other. To make a colour less intense, add a tiny touch of its complementary to the mix. For example, if a red appears too bright and strong, add a touch of green to the mix. The result will be an earthy shade.

As more green is added to the red, it will become increasingly grey and neutral. This applies to all complementary colours and is an ideal way of mixing earthy and grey shades.

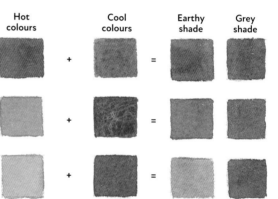

Hot colours		Cool colours		Earthy shade	Grey shade

Green mixes

There are many varied greens in nature. I like to mix greens using the different shades of blue and yellow in my palette rather than relying on ready-mixed shades. The shades of green within each colour swatch on this chart show how you can combine different blues and yellows to make green mixes that vary depending on which paint colours are used, and whether blue or yellow is more dominant within the mix.

You may like to make a similar colour chart of greens, by mixing the blues and yellows in your palette to see the slight variations in colour depending on their coolness or warmth.

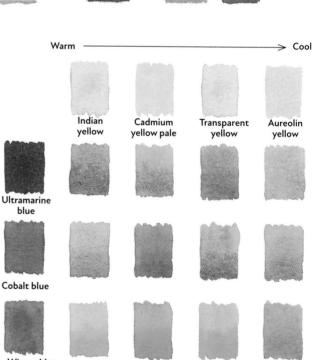

Warm ————————→ Cool

Warm / Cool

Indian yellow	Cadmium yellow pale	Transparent yellow	Aureolin yellow

Ultramarine blue

Cobalt blue

Winsor blue (green shade)

Julie's top tip

You can substitute Winsor blue (green shade) with intense blue or phthalo blue, if you prefer. Both alternatives are cool blue colours with similar properties to Winsor blue (green shade).

16

HOW TO FRAME AND DISPLAY YOUR WORK

Ready-made mounts are available to purchase. The correct size for these paintings is frame size 31 x 25.5cm (12 x 10in), image size 25.5 x 20cm (10 x 8in). Alternatively, a professional picture framer can cut a mount to fit your artwork.

When choosing a frame, select a colour that enhances your painting. A neutral ivory will work well with all of your paintings made from the projects in this book.

1 Turn your finished piece over and run strips of masking tape along the top and bottom, each half on and half off the paper as shown.

2 Turn the painting over and lower the frame into place. Press down firmly.

3 Turn the frame over again and press down firmly on the reverse as you run your fingers down each strip of masking tape to secure the painting in place.

4 Turn the frame over once more to reveal the finished picture, ready for display.

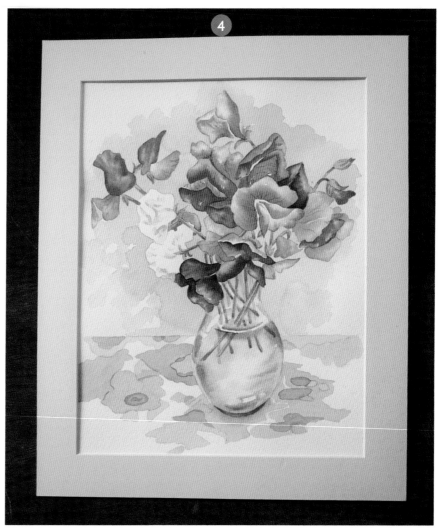

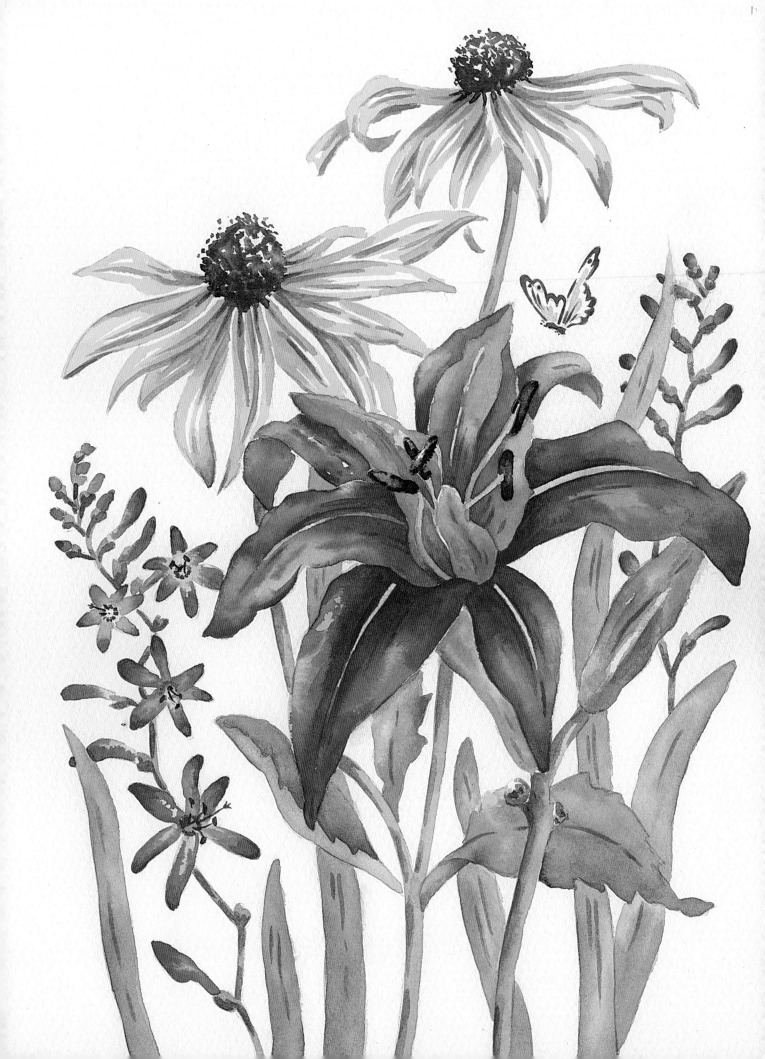

THE PROJECTS

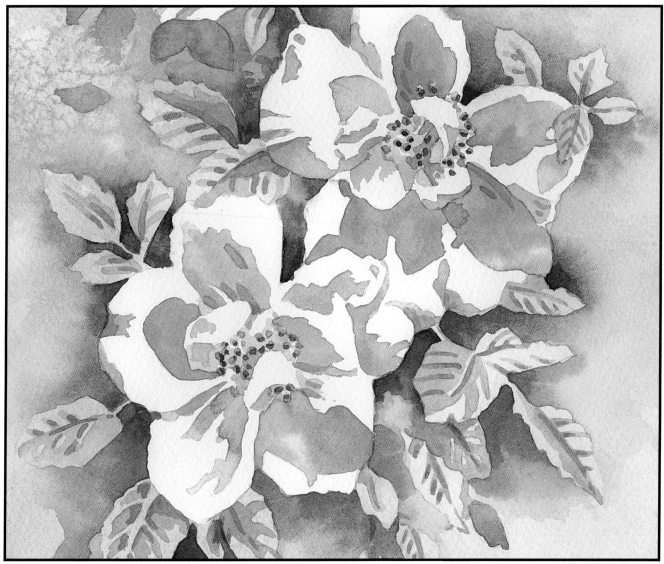

1. TULIPS

Here we put into practice the two main watercolour techniques, wet-on-dry and wet-in-wet. I have chosen to paint a background wash for these tulips, which will give you practice in painting a flat wash on a dry background. This project also shows how broad strokes of colour can be achieved by using the belly of the brush; and shows you how to use the point for fine details such as veins.

I have chosen a pale shade of pink for the background, to harmonize with the pink and mauve flowerheads and to complement the green of the leaves and stems. For the petals and leaves I have used the wet-in-wet technique, which is perfect to suggest their transparency, delicacy and form.

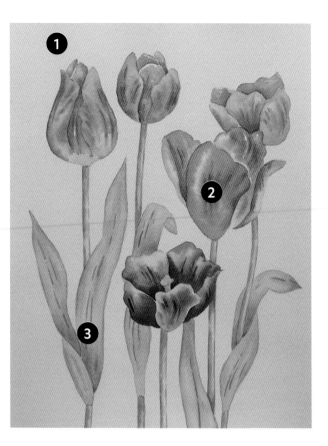

BEFORE YOU START

YOU WILL NEED
Size 10 round brush, size 6 round brush, outline 1 (see page 98)

COLOURS NEEDED
Permanent rose, quinacridone magenta, alizarin crimson, transparent yellow, aureolin yellow, ultramarine blue, Winsor blue (green shade)

Technique 1: Wet-on-dry – flat wash

This technique underlies almost every aspect of painting in watercolour. The ability to create a flat, even wash of colour is useful when painting smaller areas, and can also be used, as here, to provide an even tint for the whole background.

1 With your board at a slight angle, load a large brush (size 10 or larger) with your prepared paint. It should be watery in consistency. Starting at the top of the area you want, draw a horizontal stroke. The watery paint will flow down and form a small pool at the bottom of the stroke. This is called the bead.

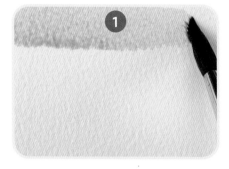

2 Lift the brush away and make a second stroke that slightly overlaps the first, picking up the bead of paint and drawing it along. Use the belly of the brush to ensure a broad, even stroke.

3 Repeat until the area is filled, reloading your brush with fresh paint as necessary. Avoid going back into the area you have painted because this will disturb the paint and give you a streaky effect. You are aiming for a flat, even effect over the whole area.

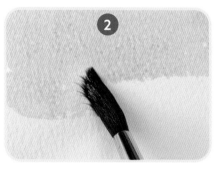

Technique 2: Wet-in-wet – creating form

When painting flowers, you are rarely called upon to paint large flat washes, so here we are going to paint within a small petal shape, introducing paint onto a wet surface. This creates a softer wash that you can use to create the form of the petal. Stronger colours can be applied into the wet wash, to further emphasize the petal's shape, including shadows and highlights.

1 Using a brush that is an appropriate size for the area you are painting – for this small petal, I am using a size 6 round brush – wet the whole petal area with clean water, being careful to stay within the outline.

2 Using paint prepared to a mid-strength (that is, neither watery nor creamy), run your brush down one edge of the outline to the bottom, then sweep a line upwards. Let the colour bleed inwards.

3 Repeat two or three times with curving lines that follow the shape of the petal, leaving some gaps in-between.

4 While the paint remains wet, strengthen the strokes made earlier with slightly creamier paint. Be careful to leave areas of the background showing. This variation of tone suggests highlights and form.

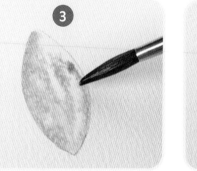
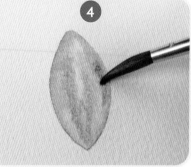
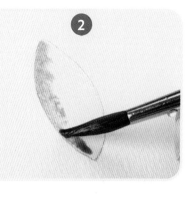

Technique 3: Painting fine lines

When painting fine details, use the point of the brush and draw it down at an angle. Make sure that the underlying paint is completely dry. Try to draw lines in one smooth, sweeping movement, rather than lots of smaller strokes.

This technique is used in this project for adding veins and other details to leaves and petals.

It is important to have a fine point on the brush. Here I am using a size 6 brush, with an excellent point, but you could instead use a smaller, size 4 brush if you feel more comfortable with it. As long as it has a good point, the brush will work well.

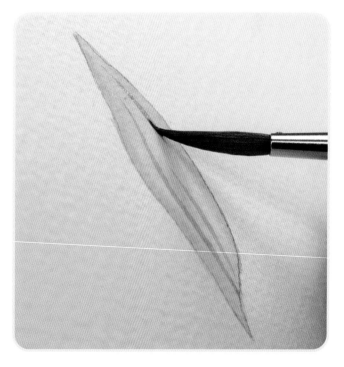

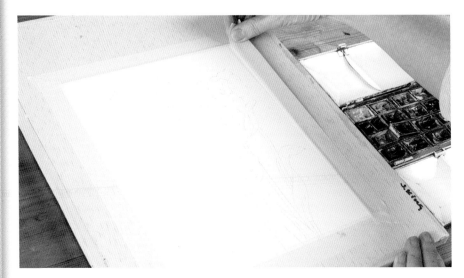

Prevent smudges Use a piece of kitchen paper to protect the surface if you need to rest your hand. This will help to prevent smudging the work.

Mix for step 8 A mid-strength pink-purple mix of quinacridone magenta with a little ultramarine blue.

Order of work If you work on non-adjacent petals, you can continue painting while the previous petal is drying, without risking the paint bleeding from one to another. This also helps to speed up the process.

For example, after finishing the leftmost petal (see step 9), I move to the rightmost petal, not to the adjacent one in the middle.

Colour choice If I had decided on a complementary green wash background (rather than the harmonizing pink) I would have painted the pink tulips first, and painted the background around them. They would have lost their freshness and appeared muddy painted on green.

THE PAINTING

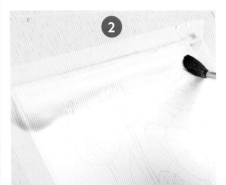

1 Trace the tulip outline onto your watercolour paper. Place the paper on your board and run strips of masking tape around the edges, covering approximately 5mm (¼in) all round. This helps to prevent it buckling. Tilt the board so that the paint flows downwards – you can use the roll of masking tape to prop the board up.

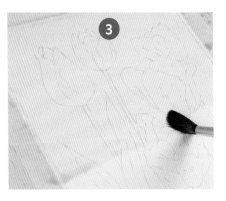

2 Prepare a well of permanent rose, watering it down to make a very pale, very watery tint of colour. Make plenty, as the brush absorbs the paint very quickly. The paint needs to be pale as later on we will paint green foliage over the top. If the pink is too strong, it will muddy the green. Load the size 10 brush with the permanent rose. Starting from the top, run a broad stroke right the way across the paper.

3 Working quickly, as you don't want to allow the paint to dry, paint as many horizontal strokes as you can with the loaded brush, overlapping the previous stroke each time and working right over the drawing. Reload the brush after every few strokes to ensure that you get an even coverage.

4 Continue working downwards until the whole sheet of paper is covered. This background wash will harmonize and unify the painting. Keep the background wash extremely pale so as not to muddy the colour painted on top.

5 Allow the paint to dry completely. Using a size 6 round brush, and working wet-on-dry, pick up a little aureolin yellow and paint the base of the left-hand tulip, where the stem meets the flowers.

6 Rinse the brush thoroughly and dab it lightly onto a piece of kitchen paper to remove excess water. The brush needs to be damp, rather than dripping wet.

7 Use the damp brush to fade the wet paint upwards, blending it away to nothing. The aim is to avoid any visible edges.

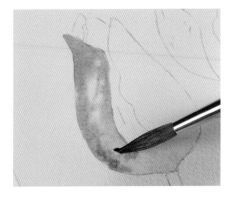

8 Prepare the mix detailed in the Top Tips box (see opposite). Use the size 10 brush to wet the leftmost petal, overlapping the yellow at the base a little, then use the point of your size 6 brush to apply the pink-purple mix wet-in-wet around the edges of the petal. Starting from the top and drawing the brush downwards along the edges, paint round the petal, leaving a lighter area in the centre.

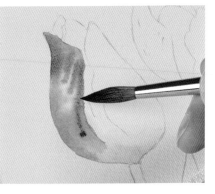

9 While the paint remains wet, strengthen the mix by adding a little more paint to the well, then suggest the direction of growth by painting finer lines wet-in-wet with the size 6 round. Because the paint is stronger, it will provide more definition, but because the paint is still wet, the result will still be soft. If the paint forms a small pool at the end of the brushstroke, quickly and gently sweep through it to diffuse it.

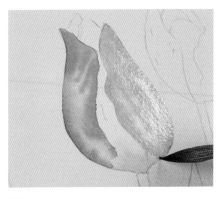

10 Paint the next petal in the same way, again leaving gaps to suggest venation.

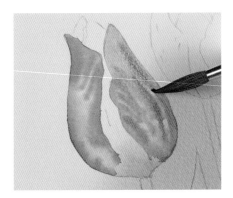

11 Use the stronger mix to suggest shape and form wet-in-wet with shorter lines towards the curling edge, and longer strokes to suggest the centre of the petal.

12 Allow the petals to dry completely, then paint the central underpetal in the same way. Use a slightly stronger paint mix to ensure a deeper tone which suggests a shadowed effect.

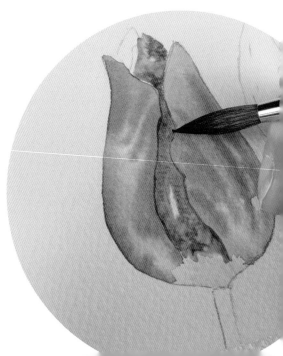

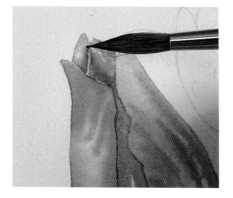

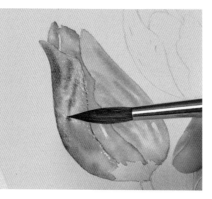

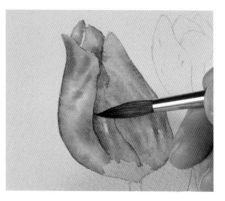

13 Work carefully with the point of the brush to leave a small gap between the separate petals near the top. This will act as a highlight.

14 Once dry, prepare a strong version (more pigment, less water) of the pink-purple mix. Re-wet the left-hand petal with clean water. Wait a few seconds, until the area is damp, rather than wet. Use the size 6 round brush to add a few directional lines to reinforce the sense of shape and 'flow' of the petal.

15 Build up the tone across the rest of the flowerhead in the same way, paying attention to shadows cast by the outer petals on the inner petals.

Julie's top tips

Making more of a mix Before starting the second flowerhead (step 16), refresh your paints so that you don't run out of paint halfway through. Don't obsess about perfect consistency when preparing more of a mix. As long as it is close enough, the slight differences will make it appear more natural: nothing in nature is uniform.

Strong and weak mixes The stronger pink-purple mix used in step 14 is the same mix as in step 8: quinacridone magenta with a little ultramarine blue. However, I have used less water and more paint here.

Colour considerations I consider the colours I am going to use before starting a painting, to unify the visual effect. I have chosen a pale pink for the background to harmonize with the pink and mauve flowerheads and to complement the green of the leaves and stems.

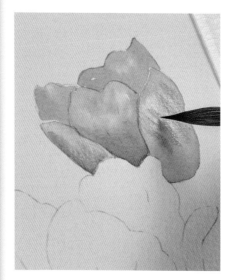

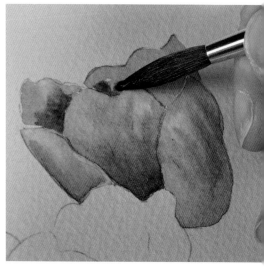

16 Working petal by petal, paint the rightmost tulip flowerhead in the same way. Look at the shapes of the individual petals, and vary the strength of tone to suit. Remember to paint non-adjacent petals, or wait until the previous one dries before continuing.

17 As you strengthen the tone with wet-in-wet painting, use the markings on the outline to help guide your brush. The slightly open tulip forms a cup shape, so use darker tones at the visible base of the rear two petals to suggest the shadow within the cup of the tulip. This creates contrast and helps to differentiate between the outer and inner petals.

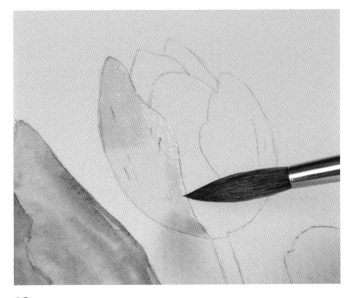

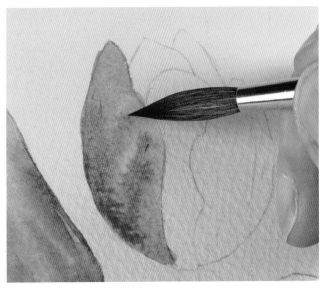

18 Prepare some aureolin yellow at a medium strength, and both a dilute and a strong well of permanent rose. Lightly wet within the first petal shape of the red tulip (to the right of the previous one), then add a hint of yellow to the tip, side and base. Blend it upwards sparingly to cover the petal while keeping the centre lighter than the edges.

19 Touch in dilute permanent rose at the edges to create a peach mix wet-in-wet. While the paint remains wet, strengthen the tone with the stronger well of permanent rose, sweeping the brush in the direction of the petal growth.

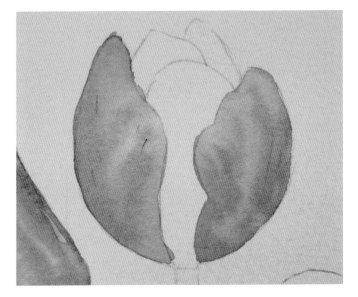

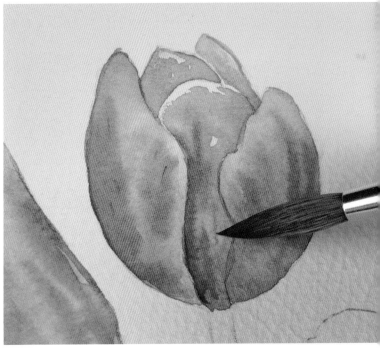

20 Use the same process to paint the right-hand petal.

21 Continue painting individual petals, re-wetting and adding more depth if required, until the flowerhead is complete.

Julie's top tips

Granulation Ultramarine blue is a granulating paint, which means that the particles of pigment sink into the texture of the paper, resulting in a wonderful, slightly mottled effect. The colour is used in all of the mixes for the dark plum tulip.

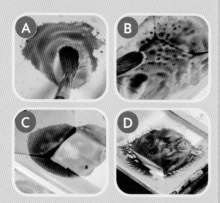

Mix for step 22 (A) Permanent rose with a hint of ultramarine blue.

Mixes for the dark plum tulip (B) warm burgundy mix of alizarin crimson with a little ultramarine blue; (C) a creamier mix made up from equal parts of alizarin crimson and ultramarine blue; (D) a cool mix of ultramarine blue with a little alizarin crimson.

Mark checking Keep a spare piece of watercolour paper to hand and use it to check the colours, consistency or type of mark you are about to make with the brush – it will help you to get the colour just right and avoid making errors on your painting.

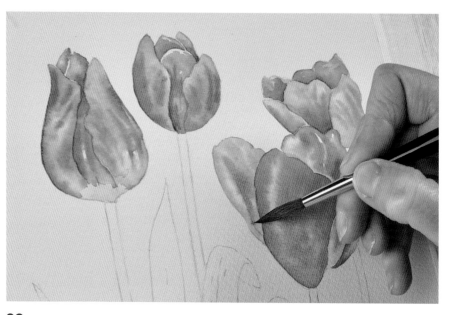

22 Refresh the permanent rose wells, and create a new well of permanent rose with a tiny hint of ultramarine blue. Paint the large open tulip using these mixes, starting with the foremost central petal. Rather than adding yellow beforehand, as with the previous flowerhead, here we are simply wetting the petals one by one and adding the permanent rose mix directly. This will give a clear, fresh pink result, enhanced by the pre-tinted background. Continue painting the other petals. It is still important to suggest the shape of each petal, so use the stronger and darker pink mixes for shading, and leave areas of highlight. Use the markings on the outline to guide you for the stronger marks.

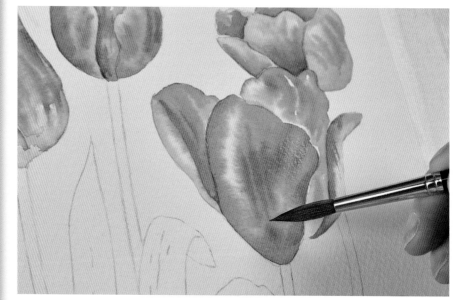

23 Once all the petals are complete, allow the flower to dry completely. Reinstate or strengthen any details you want to by re-wetting the petals individually and adding more of the stronger, creamier mixes of permanent rose with a touch of ultramarine blue wet-in-wet.

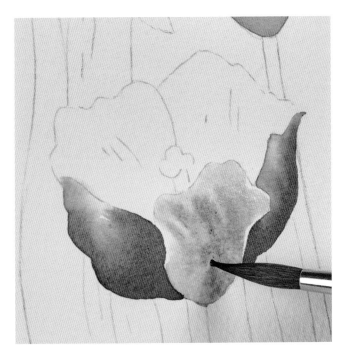

24 Prepare wells for the dark tulip: a warm burgundy mix of alizarin crimson and ultramarine blue, a creamier mix of the same colours in equal quantities, and a slightly cooler mix made with the same colours but proportionately more ultramarine blue in it. As you paint the petals of the dark tulip in the foreground, start with the warmer burgundy mix, adding it wet-in-wet to the petal, then add the creamier mix of equal parts alizarin crimson and ultramarine blue wet-in-wet. Restrict the cool mix for the darkest parts nearest the bottom of each petal, for shading and detail.

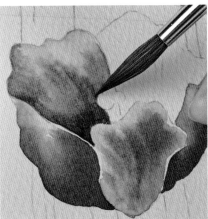

25 With the closer petals painted, start on those further away. When wetting the petals, use the tip of the brush to work carefully around the central stigma.

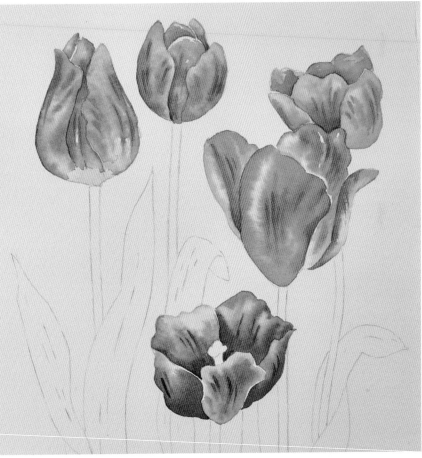

26 Allow all of the flowers to dry completely. With stronger (i.e. less dilute) mixes of the same colours on each flowerhead, strengthen the details marked on the outline using smooth, sweeping movements of the brush. If any marks appear too strong as you apply them, soften them by sweeping a clean damp brush along its edge.

Julie's top tips

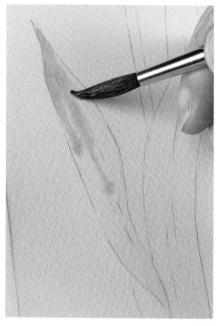

Breaking points Paint within each area indicated by an outline. The left-hand leaf twists to reveal its underside.

Leaf tip To suggest a leaf which has flowing curves, sweep your brush in the direction of the veins.

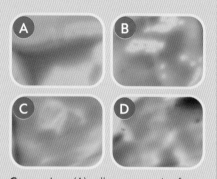

Green mixes (A) yellow-green mix of aureolin yellow with a little Winsor blue (green shade); (B) blue-green mix of Winsor blue (green shade) with a little aureolin yellow; (C) warm green mix of transparent yellow and ultramarine blue; (D) deep warm green mix of ultramarine blue with a little aureolin yellow. As you can see from mixes A and B, the result of combining the same two colours can be quite different, depending on the proportion of paint and the amount of water added to the mix.

How much to mix? When preparing mixes, there is a balance to be struck between making huge wells – at which point it becomes easy to over-dilute the paint – and continually having to mix small quantities.

I recommend moderately sized wells of relatively strong colour, as this will help ensure the colour is not over-diluted when it is added to a wet surface. As you become more practised, you will be able to quickly remix a particular shade.

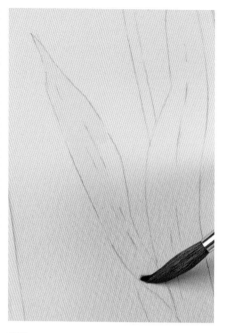

27 Still using the size 6 round brush, prepare the green mixes. The yellow-green blue-green mixes are for the leaves, while the other two are for the stems. Starting on the left-hand side, use clean water to wet the leaf down to the point where it twists to reveal the underside.

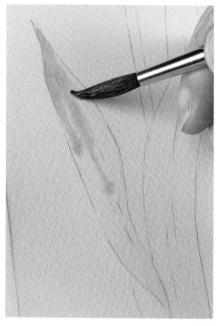

28 In a similar way to the petals, start to paint the leaf with the yellow-green mix, leaving gaps for highlights. Draw the brush downwards from the tip and upwards from the base, following the line of the curve.

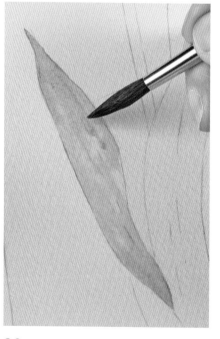

29 Working wet-in-wet, add shaping and variation with the blue-green mix. Use long strokes to suggest the veins and structure.

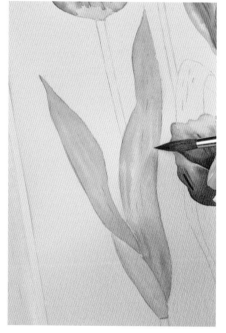

30 Paint the underside of the leaf using the same two mixes and technique, then continue with the second leaf on the stem in the same way.

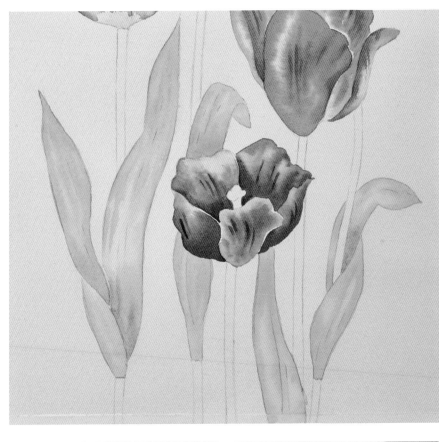

31 Paint the remaining leaves using the same mixes (yellow-green and blue-green) and techniques, paying close attention to the shaping of each part of each leaf. The areas that you leave lighter, and those you strengthen, all help to create the illusion of form.

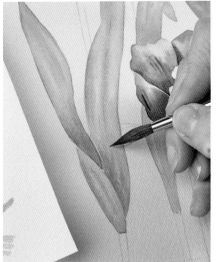

32 To strengthen further, re-wet and apply sweeping brushstrokes again, using a stronger, slightly creamier mix of the blue-green.

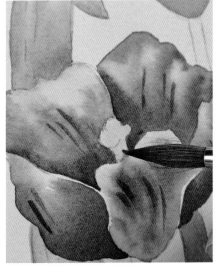

33 Working wet-on-dry, apply a base wash of the yellow-green mix to the central stigma using the tip of the size 6 round brush.

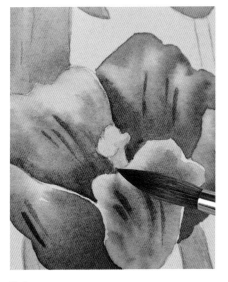

34 Working wet-in-wet, add a shadow to suggest its curved form in the blue-green mix.

35 Wet the stem and draw the warm green mix (C) along the left-hand side.

36 While the paint remains wet, quickly add the deeper warm green mix (D) to add depth, particularly on the left-hand sides of the stems and beneath the flowerheads. Lightly paint a fine broken line on the right-hand side of the stem, aiming to leave a hint of the background showing through to suggest a highlight.

37 Repeat for the other stems.

Julie's top tips

Brush size If you feel more comfortable doing so, you can use a smaller brush, such as a size 4 round, to add the final details. However, if your size 6 brush (or even larger) has a good point, you can use that just as easily.

Breaking points When painting large areas, find natural breaking points such as the edges of petals or leaves, or where the curve creates a shape, to give you distinct areas to paint. This will help to avoid areas drying before you can fill them in.

38 Provided that the leaves are thoroughly dry, add a few veins with the darker warm green mix (D), using the lines on the outline as a guide for their direction.

39 Allow the painting to dry completely, then remove the masking tape to finish.

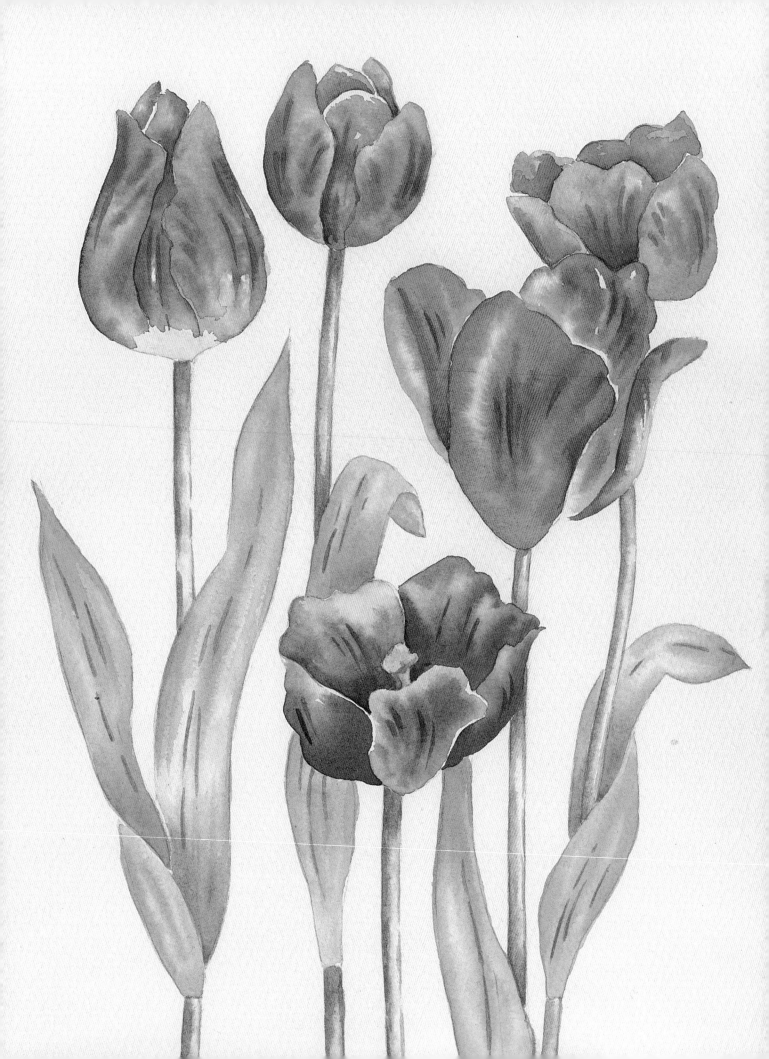

2. HIBISCUS

This beautiful hibiscus has large petals, flowing with translucent soft colours.

This project introduces you to the technique of a gradated wash wet-in-wet and wet-on-dry, a method of glazing colour to add a lightness and freshness to a background and a stippling technique to build up texture.

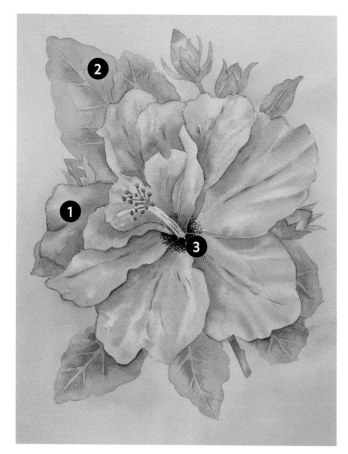

BEFORE YOU START

YOU WILL NEED
Size 10 round brush, size 8 round brush, size 6 round brush, size 4 round brush, outline 2 (see page 99)

COLOURS NEEDED
Alizarin crimson, quinacridone magenta, transparent yellow, aureolin yellow, ultramarine blue, Winsor blue (green shade), cobalt blue

Technique 1: Gradated washes – fading out

This technique produces a 'gradated wash' – one that gradually fades away in tone and intensity. Gradated washes are a technique that you can use on both dry and wet surfaces. Fading out deeper tones wet-on-dry is a good way to suggest shadows when one petal overlaps another, or in the case of the leaves, this technique can be used to fade out the colour between veins.

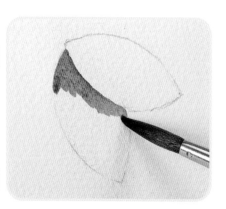

1 Using relatively thick, creamy paint, add a little paint to the part of the area you want darker.

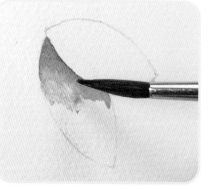

2 Rinse the brush, tap off excess water, then use the tip to encourage the paint to flow downwards and diffuse to create a lighter tone.

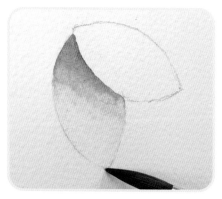

3 Continue diffusing the colour away to the edge of your shape, then allow to dry.

Technique 2: Glazing

When glazing, one thin wash is applied over another. Once the base wash has dried thoroughly, a wash of either the same colour or another shade can be painted on top. As watercolours are quite transparent the beauty of them is that the base colour can be seen shining through.

I have used the glazing technique in this project to paint the base of the leaves so that the background shows through, which adds to the variation of colour. When dry, another diffused glaze of green is applied between the veins.

 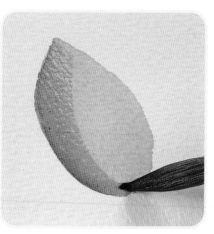 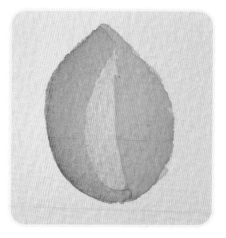

1 Paint the base colour – permanent rose in this example.

2 Allow to dry completely, then wash over a second layer of the same colour to strengthen the tone.

3 You can also glaze a different colour over it (cadmium yellow pale in this example). Owing to the translucency of watercolour, the underlying colour is not obscured (as in oils or acrylics), but instead alters the hue.

Technique 3: Stippling

Stippling is a useful method of suggesting the textured appearance in the centre of a flower. The point of the brush is used to dab up and down in a vertical position to create round marks. These can be sparse individual dots or lots of overlapping dots, which will blend into one another, leaving small gaps in between.

The size of the brush used depends on the scale of the texture required.

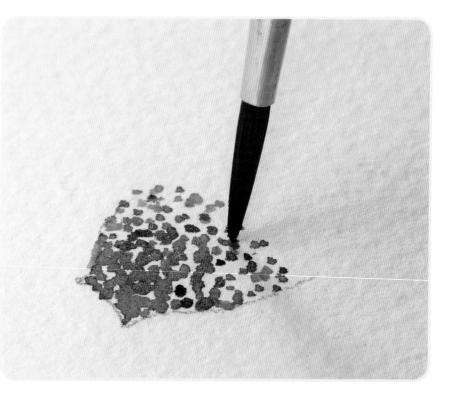

The closer together you make the dots, the denser the effect. The dark texture at the centre of the flowerhead appears to fade out as the stippling becomes more sparse.

THE PAINTING

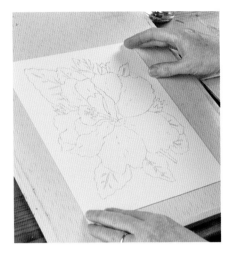

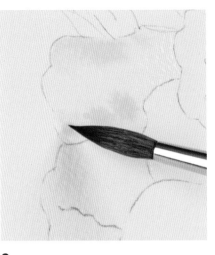

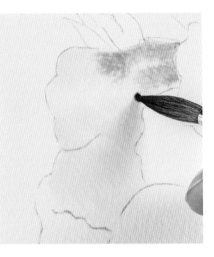

1 Trace the outline onto your watercolour paper. Set your board to a slight angle, and place the paper on your board. There is no need to tape round the edges. Prepare the mixes for the hibiscus (see below).

2 Using clean water and the size 6 round brush, wet the leftmost petal, then drop in hints of aureolin yellow wet-in-wet here and there. Apply these hints sparingly.

3 While still wet, add the quinacridone magenta, starting from the inner edge of the flower.

Julie's top tips

Work carefully As hibiscus petals are relatively complex in terms of arrangement and the way in which they relate to one another, work adjacent petals in a slower, more considered manner, rather than hopping from one area to another. Although this is slower (as you have to wait for each petal to dry), it helps to ensure that the shadows and relationships between petals are all correct. When working in this way, it is very important that each area is dry before moving on to the next one.

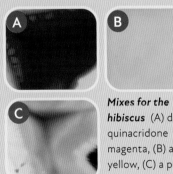

Mixes for the hibiscus (A) dilute quinacridone magenta, (B) aureolin yellow, (C) a purple mix of quinacridone magenta and ultramarine blue.

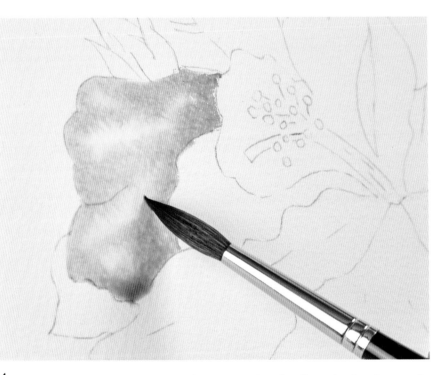

4 Continue 'cutting around' the inner edge of the outline and gently pull some brushstrokes towards the outer edge, leaving gaps to suggest highlights. The paint will gently diffuse and appear lighter towards the outer edges. Paint carefully, keeping the paint within the outlined edge.

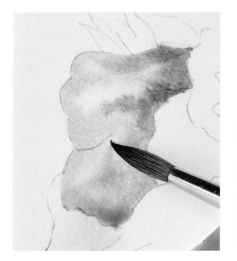
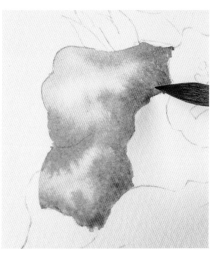
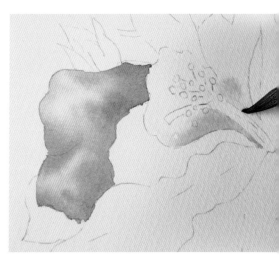

5 Add stronger touches of quinacridone magenta, using paint from the pan so that it is fairly thick and creamy. Again, use the point of the brush to drop in this stronger mix and let it diffuse into the damp base. This will helps to give the petal shape.

6 Strengthen the tone by adding a creamy consistency of the purple mix, concentrating it on the edges nearer overlapping petals. This will help to create the impression of shadow and layering.

7 While the previous petal is drying, commence the central petal surrounding the stigma. Wet the base, covering the rounded anthers, but make sure that you leave the stigma dry. Add quinacridone magenta again, cutting around the dry edge of the stigma.

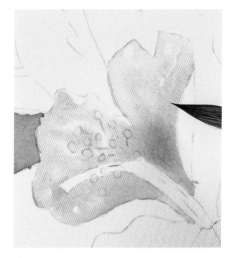
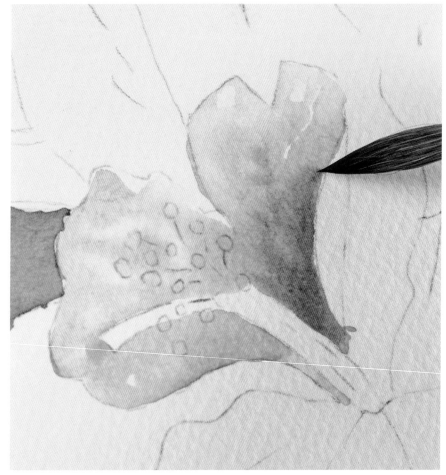

8 Continue sweeping the paint towards the outer edge, and drop in hints of the purple mix.

9 Add a few brushstrokes of the creamier quinacridone magenta to help develop the form. Use the tip of the brush to draw and direct the paint, to give shaping. Add the purple mix for variety and shading.

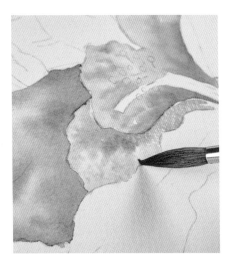

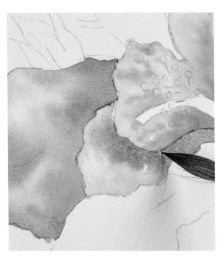

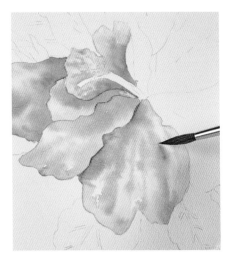

10 Allow the central area to dry, then move on to the next petal. Follow the same sequence as the first.

11 Add strong quinacridone magenta to the very edge near the top, creating a darker, richer tone for shadow.

12 Continue painting the petals one by one, working in an anticlockwise direction and using the previous petals to help you with placement of shadows and highlights. Remember always to work from the centre of each petal out to the edge, along the path of growth and in the direction of the veins.

Julie's top tips

Step back It's easy to focus entirely on each petal in isolation, but you risk getting the tone wrong. Look at the overall effect, and how each petal relates to the others.

Relinquish control Beyond keeping the colour stronger towards the centre of the flower, and working your brushstrokes outwards from the centre, avoid being too controlling with the paint. Instead, allow it to blend and merge organically on each petal. One of the great joys of the medium is allowing it to surprise you – if you repeat this project, the result will be different.

Using the right brush When adding flowing lines, you may find a smaller brush easier to control. The fineness of the point is more important than the size of the brush.

Mix for step 17 A stronger mix than that used earlier, but with the same proportions of quinacridone magenta with a little ultramarine blue.

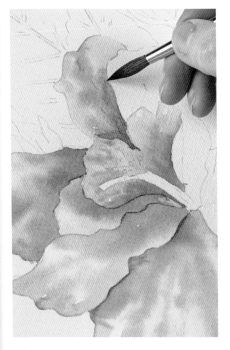

13 Once you have finished the lowest petal, recommence at the top and work in a clockwise direction, so as to avoid the risk of smudging or smearing the paint as you work. Note that the direction you work around the petals depends on whether you are left- or right-handed and whichever way you find most comfortable.

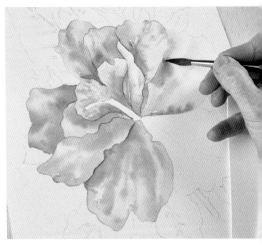

14 Continue working clockwise round the flower, petal by petal. If you feel that a petal is too pale, leave it to dry, re-wet and work exactly as before so to retain a soft appearance. Alternatively, glaze a soft wash of colour on top of a dry base (not necessarily all over) and diffuse with water. Note that I am using a piece of kitchen paper to protect the paper surface from my hand as I work and to avoid leaning on the wet paint.

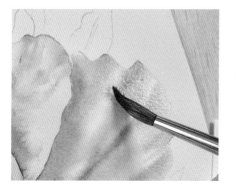

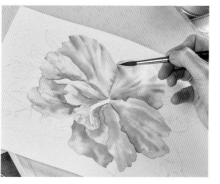

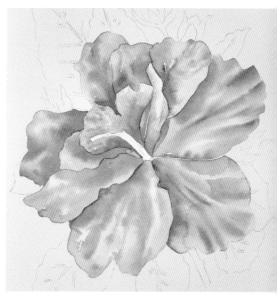

15 The right-hand petals have a more frilly outline. To suggest the form of the frill, apply the base colour as before; then, using stronger quinacridone magenta, draw the brush in from the outer edge, pressing down firmly to achieve a broader brushstroke, sweeping it to a point towards the centre while gradually lifting the brush.

16 As you come to the last petals, you may start to feel constrained – feel free to move the paper itself to help give you more control with your brushstrokes.

This completes the first wash stage. Once it is completely dry, we can begin to add depth to the recesses and shadowed areas to give the flower more form and structure.

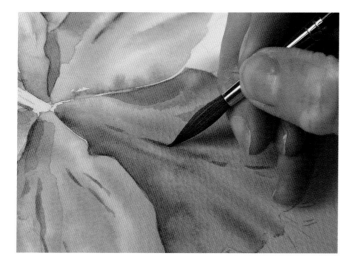

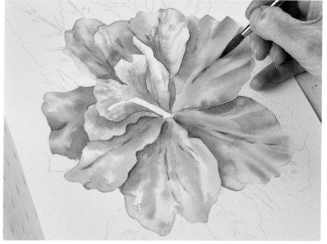

17 Make a stronger mix of quinacridone magenta with a little ultramarine blue, and use this to reinforce the darker areas of the petals. Working wet-on-dry, apply the colour along the edges which appear in shadow cast by the one above, and quickly diffuse with water to fade the colour out into the base wash. Add a few dashed marks, using the outline to help with placement.

18 Use the gradated wash method to strengthen the tone on the rest of the petals in the same way, and continue to suggest the finer shadowed recesses as described in step 17. If you feel uncertain about using the size 6 brush for these details, you can change to a size 4 round for this.

Julie's top tips

Complementary colours I have applied a pink-mauve mix on top of the golden yellow to give form and depth in step 22. Mauve and yellow are complementary colours; when mauve is painted on top of, or mixed with warm yellow, it becomes a rich earthy shade. If, however, there is too much blue in the mauve mix, the resulting colour will be closer to grey.

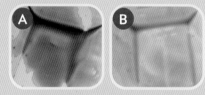

Mixes for step 19 (A) pinky-mauve mix of quinacridone magenta and ultramarine blue, stronger and more purple than the mix used earlier; (B) golden yellow mix of transparent yellow with a touch of quinacridone magenta.

Mix for step 25
Alizarin crimson and ultramarine blue – very dark and strong.

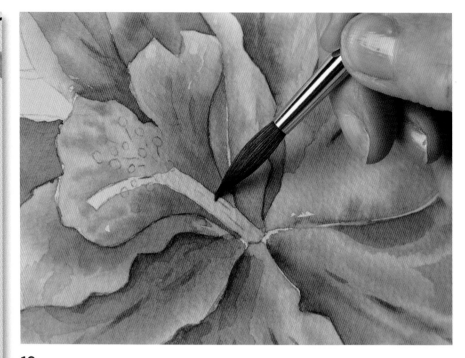

19 Still using the size 6 round brush, paint the base of the central column with the golden yellow mix. Apply the colour wet-on-dry at the base and diffuse it with water in an upwards direction to fade it out.

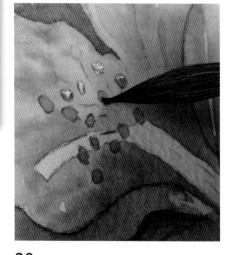

20 Paint the anthers with a stronger mix of the same colour. Use the very tip of the brush to touch on these small areas. Aim to create a flat, even effect that stands out on top of the pink.

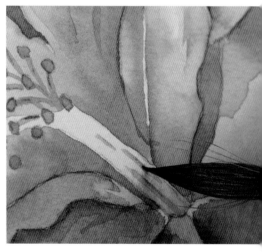

21 Once the base is dry, use the same mix to suggest the filaments, and to pick out the lines on the column.

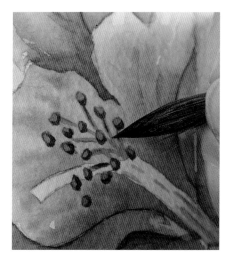

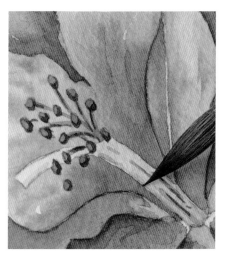

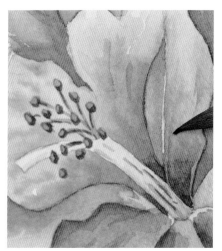

22 Add a tiny curved shadow at the bottom of each anther with the pinky-mauve mix, then do the same with the filaments to suggest their form.

23 Use very dilute ultramarine blue to suggest shadow on the column.

24 Strengthen the shade of colour on the top two petals, behind the stigma, to suggest depth and recession, using a purple-pink mix of quinacridone magenta and ultramarine blue. Apply the colour wet-on-dry and diffuse it away.

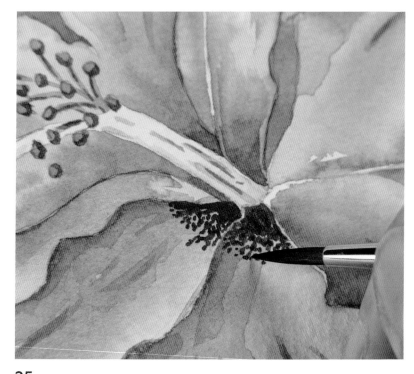

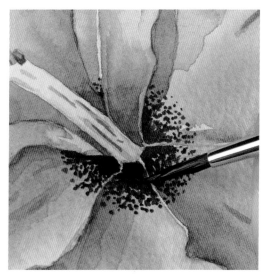

26 Add more ultramarine blue to the mix to make it creamier, and strengthen the inner part of the markings to add depth.

25 Make a very dark mix of alizarin crimson and ultramarine blue. Change to a size 4 round brush and draw fine lines radiating out from the centre of the lower petals. Continue with a stippling motion to add some broken dots extending beyond the lines so that the markings appear to gradually fade away by becoming more sparse.

Julie's top tips

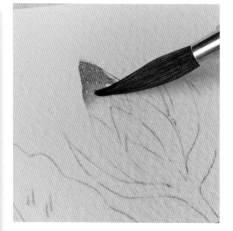

Clean and fresh To ensure the best and most vibrant effect for the background, make sure that you have two jars of water, keeping one fresh for diffusing colour. It also helps to use two brushes: a size 8 brush to apply the paint and a size 10 to add water to the paper surface when diffusing the colour.

Background notes The base colours in the background will show through the colour which is glazed on top. If yellow is glazed over blue the result will be green. The mottled effect of the background enhances the foliage when colour is applied on top in this project. Keep the background quite pale so that the green leaves will show up when painted on top.

Thinking ahead When creating backgrounds like the one in this painting, it is important to leave gaps in the first colour you apply, so that you achieve the greatest variety of colours when the second is applied. By leaving some gaps in the yellow, you will also get pure blues and blue-greens when the blue is added.

Starting points Where possible, start under a leaf or similar area when painting a background like this. Because you will work over these areas later, it helps to hide any strong lines if one should appear while you work.

27 Using the same quinacridone magenta as for the petals, add the colour to the tip of the first bud, and fade it out towards the base with clean water.

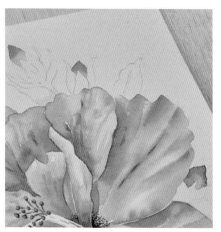

28 Repeat the process for the other two buds.

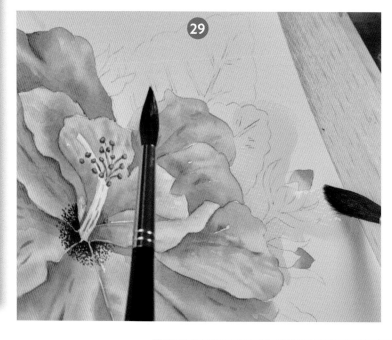

29 Prepare a well of Winsor blue (green shade) and a well of transparent yellow. Load the size 8 brush with transparent yellow and begin to paint the background, wet-on-dry, in sections. Cut around the petal edges and use a size 10 round brush to diffuse the colour with water, in order to to achieve a gradated wash effect while covering the leaf outlines.

30 Build the background up gradually, spreading the colour with water to vary the tone. Alternate the transparent yellow and the Winsor blue (green shade) along the edge of the flower, letting the colours overlap in parts to create a fresh green shade.

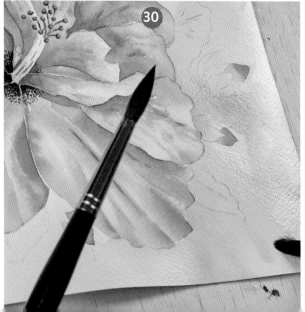

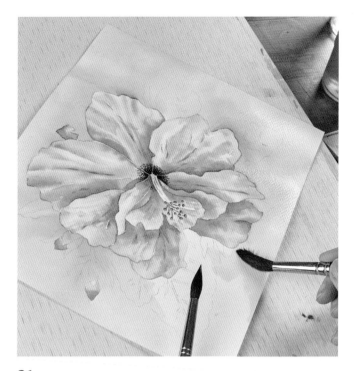

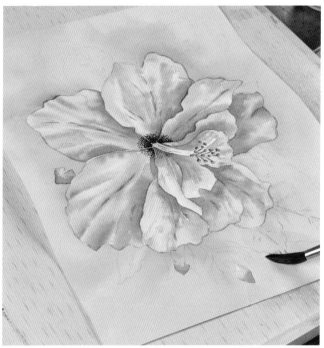

31 Continue building the background up all the way round, turning the paper to give you more control.

32 As you reach your starting point, be careful to work past it, to avoid an unnatural strong line.

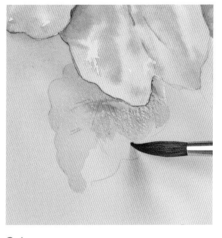

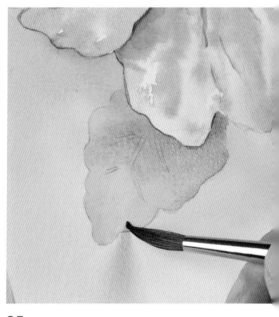

33 Once the background has dried completely, prepare wells of aureolin yellow, Winsor blue (green shade) and cobalt blue. Use a size 6 round brush to glaze the yellow on part of one of the leaves. Where the yellow overlays the blue background, it will appear quite green.

34 Apply Winsor blue (green shade) on the other side of the leaf, allowing the colours to blend. A touch of cobalt blue under the petal edge will create a little shadow.

35 Draw the colour along the edges to mix freely with the yellow, which results in a varied mix of shades of blue and green.

Julie's top tips

Transparency These stages demonstrate the transparent quality of watercolour. I have used the same colour throughout to glaze the areas between the veins; but note how the underlying colours – more blue or more yellow – affect the result, creating a great variety of shades. The background shades are the palest tones, which stand out as the veins.

Mix for step 38 Transparent yellow and Winsor blue (green shade) in equal proportions.

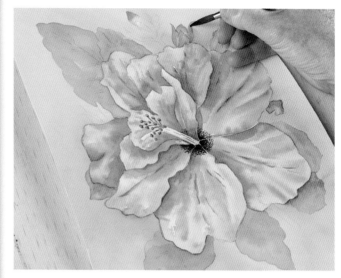

36 Paint the other leaves and foliage in the same way. As you come to the sepals of the buds, paint the outer set first, followed by the inner part with a stronger tone to help differentiate between the two. Make sure the outer sepals are dry before starting the inner part.

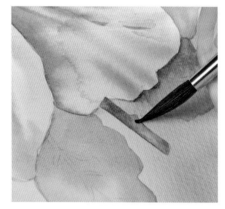

37 The stem is treated in the same way.

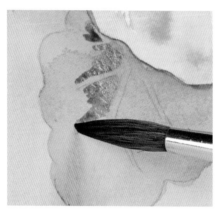

38 Combine transparent yellow with Winsor blue (green shade) in equal proportions. Working wet-on-dry, overlay the leaves with this mix, leaving spaces for the veins as shown.

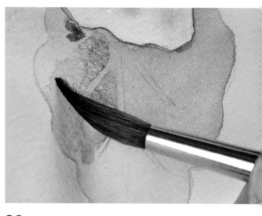

39 Working quickly, rinse the brush and soften the colour towards the edge with a damp brush.

40 Paint all of the remaining leaves in this way to finish. Feel free to rotate the painting to help you reach certain areas.

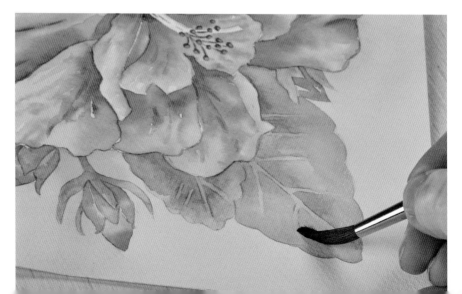

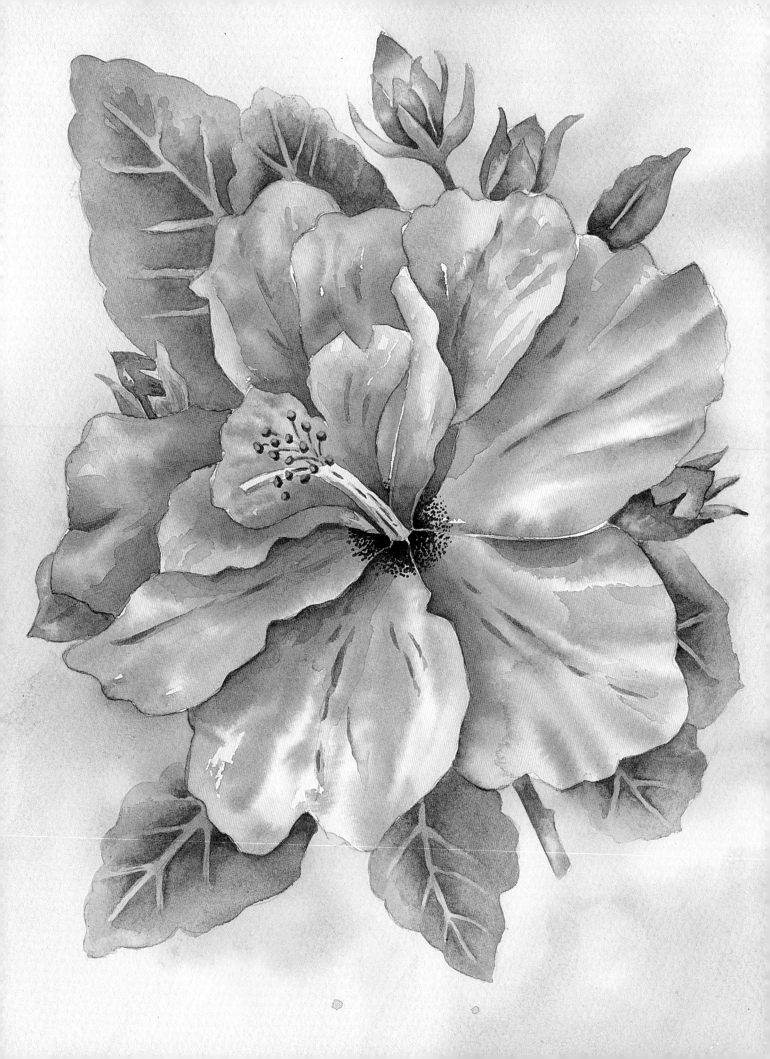

3. DAY LILY AND RUDBECKIA

These flowers create a dramatic and stunning arrangement, suggesting a hot summer's day. The smaller crocosmia flowers and the butterfly add to the ambience.

Instead of approaching the flower and leaves by wetting the paper with water beforehand, as in the previous two projects, we will use a direct painting method and work wet on a dry surface. This allows the colours to merge, and the brush can be controlled – with varying amounts of pressure – to create sweeping petal shapes, leaves and stippled dots; ideal for these varied flower centres.

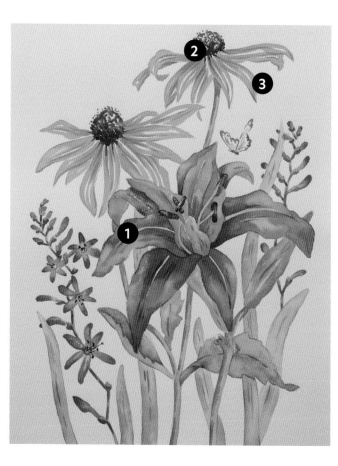

BEFORE YOU START

YOU WILL NEED
Size 6 round brush, size 4 round brush, size 4 nylon brush, outline 3 (see page 100)

COLOURS NEEDED
Scarlet lake, alizarin crimson, quinacridone magenta, cadmium yellow pale, ultramarine blue, Winsor blue (green shade)

Technique 1: Vibrant shades – letting colours mix on the paper

The excitement of watercolour lies in being able to let two colours bleed into one another to create a partial mix on the paper. The shades created in this way are far more varied than if the same two colours are pre-mixed in a palette, which creates a uniform shade.

These two petal samples illustrate how two primary colours can mix to create a secondary colour, while retaining a varied shade, and how the mix of the two colours, directed by a few sweeping brushstrokes, can indicate shape and form.

Yellow and red paint mixing to form orange

Pink and blue paint mixing to form purple

Technique 2: Wet-in-wet stipping

Stippling (see page 33) can be worked wet-in-wet, too. The effect will be softer when working wet-in-wet than wet-on-dry.

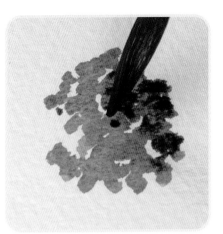

STIPPLING WET-ON-DRY

As described on page 33, a dabbing motion is used to apply small dots of paint onto a piece of dry paper with the point of the brush. The dots overlap one another in places, and small gaps of white paper are left in between.

STIPPLING WET-IN-WET

Wet-in-wet stippling will result in the dots of paint gently diffusing into the wet base. Holding the brush in a vertical position, stipple as for wet-on-dry (see left), but work more sparingly into the wet base.

Technique 3: Press and sweep

Painting petals with this technique helps to suggest movement. Rudbeckia and similar star-shaped flowers, such as sunflowers, lend themselves to this technique, as their slender petals taper off to a point.

Two or three direct dry brushstrokes are swept in the direction of the growth of the petals. By leaving a hint of white paper in between each stroke, you will give the petal a highlight and suggest the direction of the veins.

1 Use the belly of the brush to apply a fairly broad line.

2 Using a smooth sweeping stroke, gently increase the pressure to broaden the line.

3 Continue to draw the brush along, gradually releasing the pressure and lifting the brush off the paper as you approach the end point, in order to taper off the line.

Julie's top tips

Yellows Cadmium yellow pale is a strong, opaque yellow. Paints like this are good when working wet-on-dry, as they give good coverage and have a lot of impact.

Yellow is a light tone, and, as a result, the outline on the paper can be more obvious than when you are using other, darker, paints. Adding deeper, warmer tones over the outline in appropriate places can help to reduce and conceal the outline.

When applying the golden yellow mix on top of the cadmium yellow pale, the result will be softer if added when wet, but if applied dry, you will create the impression of texture and veining.

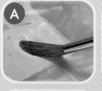

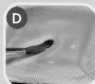

Mixes for the rudbeckia (A) golden yellow mix of cadmium yellow pale and scarlet lake; (B) brown-gold mix made by adding more scarlet lake and a little ultramarine blue to the golden yellow mix; (C) strong purple mix of ultramarine blue and alizarin crimson; (D) dilute well of the golden yellow mix (see above).

Complementary colours In step 7, we add ultramarine blue to the mix because blue neutralizes its complementary colour, orange (see page 16). The result is that the orange is made less intense.

THE PAINTING

1 Trace the outline onto your watercolour paper. Run a strip of tape along the top of the paper to secure it to the board, then prop the board up at a slight angle. Prepare the mixes for the rudbeckia flowers.

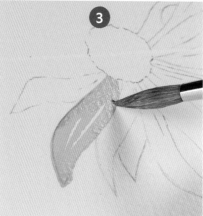

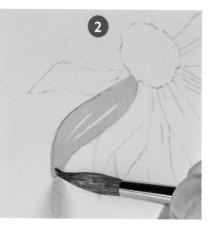

2 Load the size 6 round brush with cadmium yellow pale. Working outwards from the centre, use the press and sweep technique (see page 45) to draw the tip of the brush along the top edge of a rudbeckia petal, then repeat along the centre, then along the bottom edge, leaving a few white spaces as highlights.

3 Drop in a little of the golden yellow mix near the centre of the flower, for added warmth and slight variation of colour.

4 Leaving a small gap of white paper in between, start to paint the other petals in the same way. It is important to use confident brushstrokes that follow the shape of the individual petal, as mistakes can be obvious when using cadmium yellow pale.

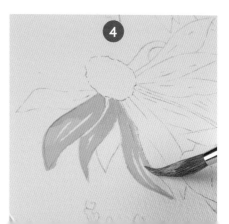

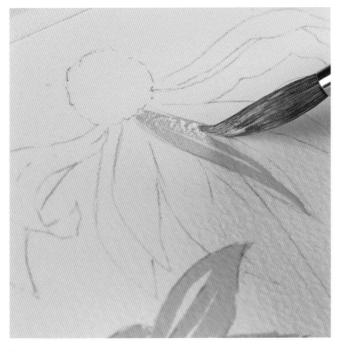

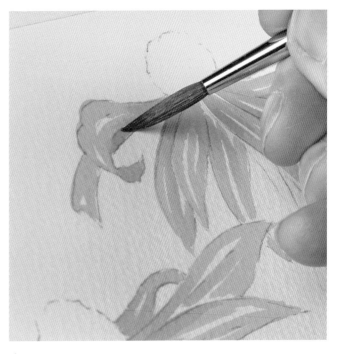

5 With the first rudbeckia flowerhead complete, paint the second flowerhead using the same technique, paying attention to the individual shapes of the petals.

6 Where one petal overlaps another, add a little more of the golden yellow to the part in shadow to help to differentiate between the two.

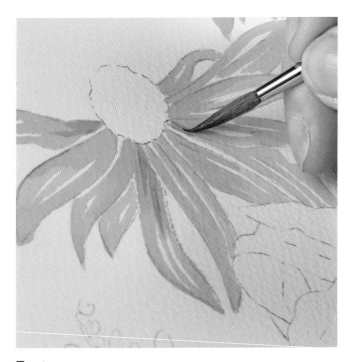

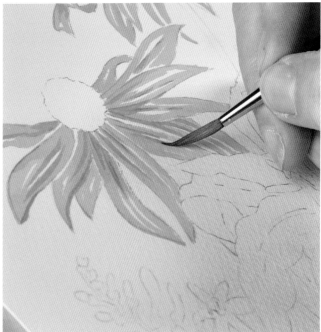

7 Using the size 4 brush and the brown-gold mix, define a few of the recessed shadows in the petals, using the marks on the outline as a guide.

8 Continue adding the veins and shadows using the same brown-gold mix.

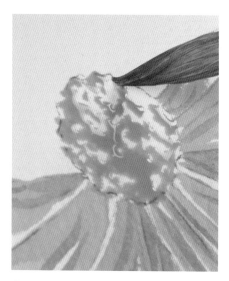

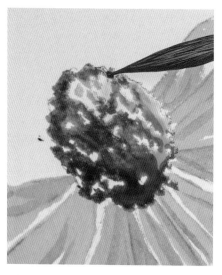

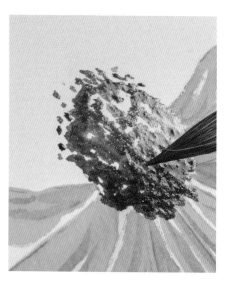

9 Load the size 6 brush with the dilute golden yellow and stipple the centre of the left-hand rudbeckia. Leave a few gaps, but don't worry about the dots flowing together; you're not aiming for definition with this wet stippling.

10 Rinse the brush and load it with the purple mix, then stipple over the centre, working wet-in-wet. Avoid the top right-hand area to suggest a highlight there.

11 Use the purple mix to add dry stippling around the top of the centre as shown. Add a little more ultramarine blue to the purple mix while you allow the centre to dry a little – not completely – and stipple over the lower left-hand side to create shadow.

Julie's top tips

Crocosmia When painting the base of the crocosmia flowerhead (the smaller flowers), allow the yellow to dry slightly, so that when the red is applied it will not flow too far towards the centre, concealing the yellow base, but will remain towards the outer edges and sides.

Brushes The sable brushes I use have very fine points – an example is shown on the left in the picture below. Crocosmia have very round edges, so I find a nylon brush (below right), which has shorter, less tapered bristles, more suitable for painting them.

This will vary by manufacturer and by brush, so do experiment with different brushes. Look for a brush that you feel comfortable using; painting should be a pleasure.

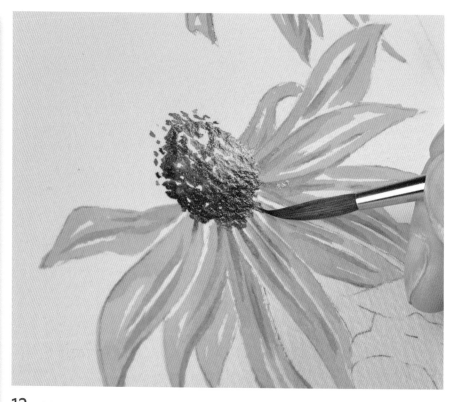

12 While the paint remains damp, use a clean size 4 brush to draw small amounts of the dark mix outwards from the centre. This adds some more depth and detail, and provides a tonal link between the petals and the centre.

13 Paint the other rudbeckia centre in the same way.

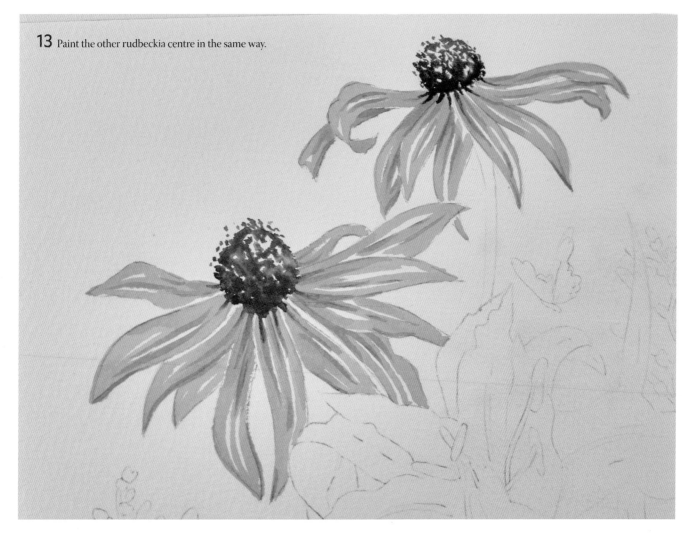

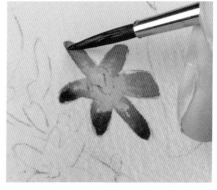

14 Prepare the following wells: strong cadmium yellow pale, strong scarlet lake, and a strong alizarin crimson. Using the size 4 nylon brush, and working wet-on-dry, paint one of the rudbeckia flowers with cadmium yellow pale. Work from the outer edge of the petal and draw the colour inwards.

15 Add a little water to the yellow and cover the centre with paint. While the base is just damp, add scarlet lake towards the tip of each petal and draw it inwards.

16 While the paint remains slightly damp, add alizarin crimson to the very tips of the petals, allowing the colour to bleed inwards. There is no need to encourage it; allow the paint to move of its own accord.

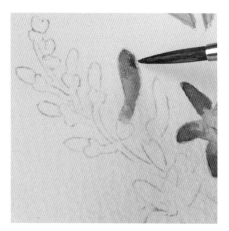

17 Follow the same process for the buds, treating them like a single petal.

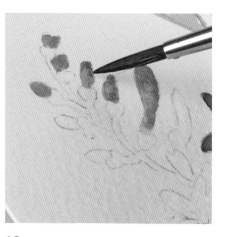

18 The smaller buds, near the top of the stem, are so small that you can paint a few at a time without risking them drying.

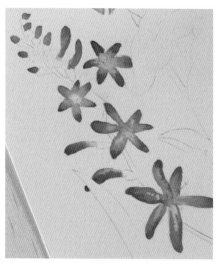

19 Continue painting the rest of the crocosmia as described. The largest flowerhead is large enough that some additional brushwork can be used to add a sense of movement. Draw the brush in from the tip, working alongside the edges of each petal.

Julie's top tips

Mix for step 21
A rich pink mix of alizarin crimson and ultramarine blue.

Mix for step 24
A rich purple mix of alizarin crimson with a little more ultramarine blue.

Painting the day lily While you are creating a variegated finish to each petal, suggest the shape and flow of both the individual petal and the flower as a whole. In addition, pay careful attention and avoid the stamens and other petals while you work. Let each petal dry before working on the adjacent one, or paint non-adjacent petals, to avoid paint spreading from one to another. I think it is worth taking things more slowly, in order to avoid any accidental mistakes.

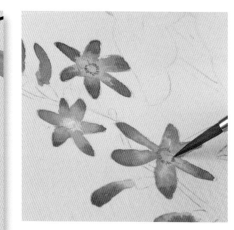

20 Paint the crocosmia buds on the right-hand side of the composition; then, still using the size 4 nylon brush, add tiny short brushstrokes of alizarin crimson in the centre of each crocosmia bloom to form a circle as shown.

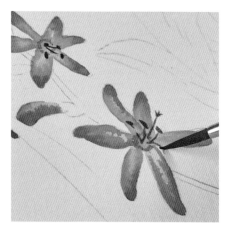

21 Using the tip of the brush, add the fine filaments and the oval-shaped anthers using the rich pink mix.

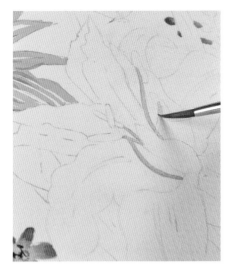

22 Still using the size 4 brush, paint the filaments on the day lily with direct brushstrokes using a mix of cadmium yellow pale with a tiny hint of scarlet lake. Allow the filaments to dry completely before continuing.

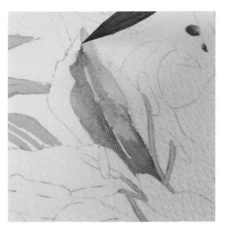

23 Using the size 6 brush and working wet-on-dry, paint the inner petals of the day lily with cadmium yellow pale. Vary the tone of the yellow by diffusing it on the surface with water. Leave a fine line in the centre to indicate the central vein and sweep in scarlet lake while damp.

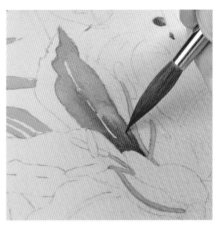

24 While the paint remains wet, apply a thicker mix of scarlet lake, starting it off strongly at the base of the petal and drawing the brush towards the tip of the petal. Aim to create a variegated effect, so that different tones of orange are visible. While it remains wet, add a little of the rich purple mix at the base of the petal, to give added depth and shade.

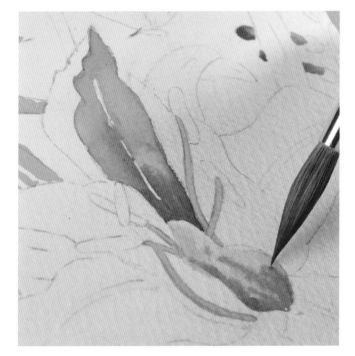

25 Start to paint the other petals surrounding the stamens, working carefully and waiting for each to dry before moving on to the next. Use slightly stronger tones against the stamens so that they will stand out.

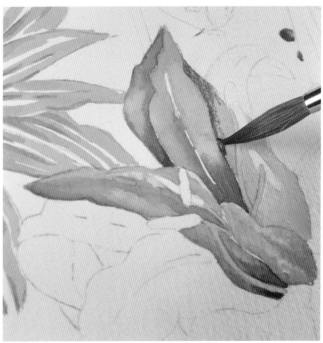

26 Continue to build up the day lily's inner petals; using the strong scarlet lake and the darker rich pink mixes to give depth and richnes. This will help to define the edges of each petal naturally – avoid painting an outline all the way around, look for areas where you can add shadow and shape naturally.

Julie's top tips

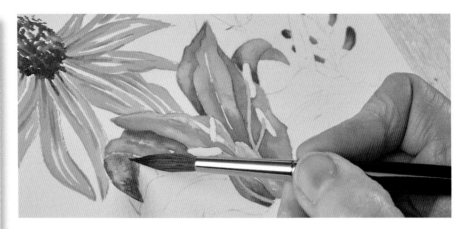

Day lily petals The larger petals offer a good canvas for detail and interest, so feel free to suggest lines that follow the direction of growth. Pay attention to small areas, too – they are as important as large parts in creating a sense of realism. Use the tip of the brush to drop in the colours on parts like the underside.

Purple shading Although the purple mix helps create strong tones and adds variation, do not overuse it, as the petal will quickly become brown.

Mixes for the details (A) pink mix of alizarin crimson with a little ultramarine blue; (B) rich purple mix of ultramarine blue with a little alizarin crimson added.

Glaze for a glow Adding a glaze of colour at step 32 will add a glow to a petal; it will emphasize the form and enrich the colour. You don't have to glaze the whole petal; use the glazing technique (see page 33) to add to the sense of shape and richness of colour.

27 With the inner petals of the day lily completed, start to paint the larger, outer petals. While these do not overlap one another so much, it is important to make them stand out. Use stronger scarlet lake along the edges which appear in shadow to help give them impact.

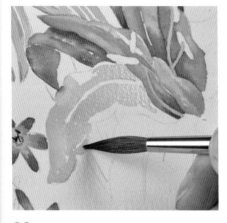

28 Leave a central channel clean in the large petals at the front, to indicate a vein.

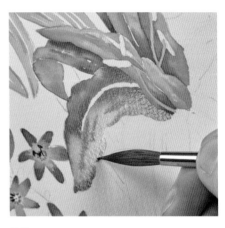

29 Once a varied wash of cadmium yellow pale has been applied to the large petals, adding the scarlet lake wet-in-wet around the edges will help to create its shape and form.

30 Paint the remaining petals of the lily using the same techniques, then paint the central column leading to the petals using more dilute mixes of the same colours (i.e. with additional water added). The column is partially hidden behind a petal.

31 Paint the bud in the same way, but with more dilute mixes. Add a hint of the purple mix to suggest shadow.

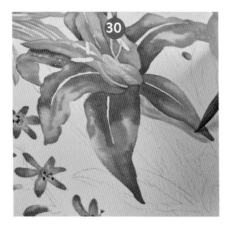

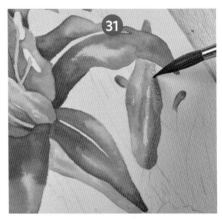

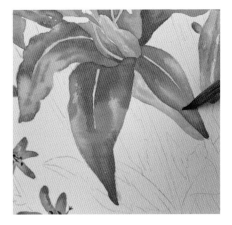 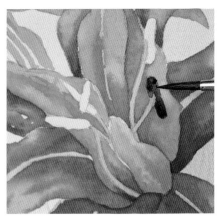 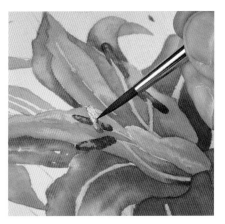

32 When dry, glaze cadmium yellow pale over parts of the outer petals, covering the central veins to remove the harshness of the pure white paper, and to selectively warm and strengthen the colours. A hint of purple shading towards the centre and tips of the petals can be added to give more depth and shading.

33 Prepare the mixes for the details. Change to the size 4 nylon brush and paint the entire shape of the anther with the pink mix. While it remains damp, stipple touches of the purple mix around the edge to create form.

34 Paint the other anthers in the same way. When adding the deeper shades, leave areas of the lighter pink mix showing through nearer the top to suggest the form. If required, the stamens can be strengthened, once dry, with more stippling of a slightly stronger rich purple mix.

35 Change to the size 6 round brush and use the tip to draw a few markings on the day lily petals and the bud with the pink and purple mixes. The lines are shown on the outline, but feel free to add a few extras of your own.

Julie's top tips

Clean greens You should always rinse your brush between colours, but it is critical to do so with these mixes to avoid muddying your fresh wells. As the mixes include blue, yellow and red, these three primaries all combine to make a grey.

Powerful blue Winsor blue (green shade) is a powerful colour, so dilute it well to avoid it being too overpowering. Sufficiently diluted, it should appear almost duck egg blue on the paper. Alternative blues that can be used in its place are phthalo blue or intense blue. Other cool blues, such as cerulean blue, can work too; though this colour is not as strong as Winsor blue (green shade), and is also opaque, rather than transparent.

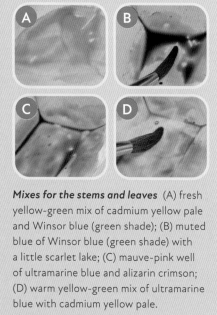

Mixes for the stems and leaves (A) fresh yellow-green mix of cadmium yellow pale and Winsor blue (green shade); (B) muted blue of Winsor blue (green shade) with a little scarlet lake; (C) mauve-pink well of ultramarine blue and alizarin crimson; (D) warm yellow-green mix of ultramarine blue with cadmium yellow pale.

Harmony The mauve-pink mix used for the shading on the crocosmia stems (see step 41) is similar to that used for the anthers in the day lily and the centres of the rudbeckia. This use of similar colours helps to unify the whole painting.

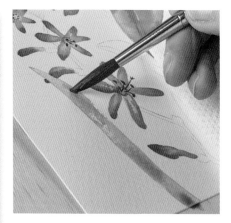

36 Prepare the mixes for the stems and leaves, and a separate well of dilute Winsor blue (green shade) for the base of the leaves. Load the size 6 brush with the Winsor blue (green shade) and paint the leftmost leaf wet-on-dry. Touch in the fresh yellow-green mix wet-in-wet.

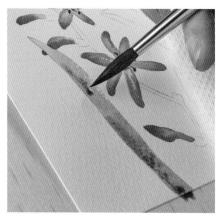

37 While wet, add areas of the muted blue to create shape, depth and form.

38 Paint the remaining leaves in the same way.

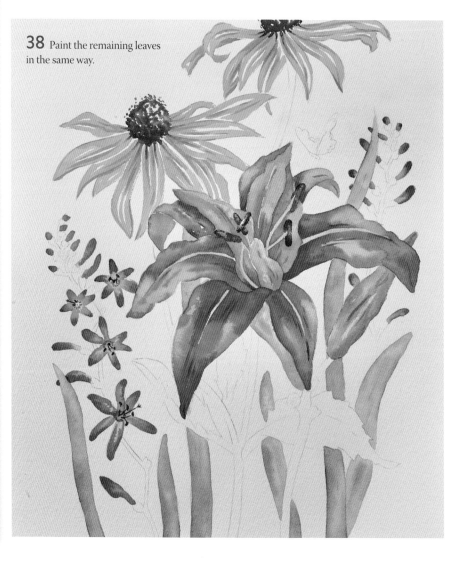

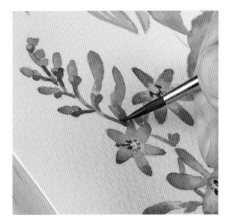

39 Add details and lines using the muted blue mix with a touch of cadmium yellow pale added. These darker grey tones help to balance the leaves with the deeper shades of the flowers, and lifts the overall composition. As before, the marks on the outline can be used to guide you, but feel free to add more if you wish.

40 Paint the crocosmia stem with the warm yellow-green, applying the paint with the size 6 round brush. For the heart-shaped calyces, aim to paint each in two small strokes.

41 Use the mauve-pink mix to overlay and mute the crocosmia stems in the areas of shadow.

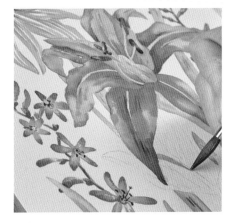

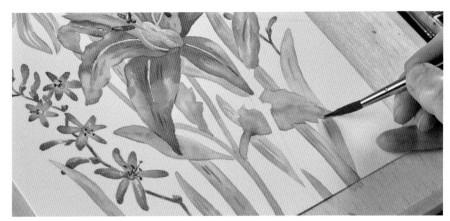

42 Use the fresh green mix to lay in a flat wash on the rudbeckia stems.

43 Lay in a variegated wash on the rudbeckia leaves, applying the cadmium yellow pale and softening it slightly with clean water, then adding both the fresh green mix and Winsor blue (green shade), allowing the colours to merge. To add interest to the leaves, paint areas of the leaf surface in yellow and areas in blue or green, allowing the colours to merge together rather than applying yellow over the entire base as we did with the day lily petals. The result will be a vibrant and fresh mix.

44 Once the leaves have all dried, use the warmer, stronger yellow-green mix to paint the inner area of the leaf on the left of the centre. Add depth against the serrated edge using the tip of your brush, then diffuse the colour away with clean water to avoid a hard, artificial line.

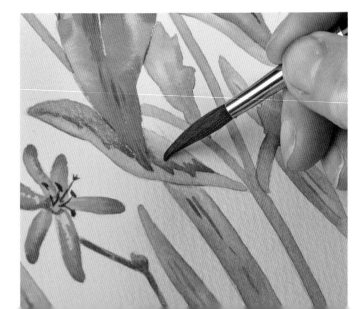

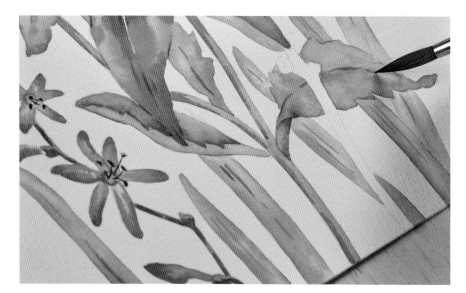

45 Use the stronger warm yellow-green mix and the fine line technique to add shading to the remaining rudbeckia leaves and stems.

46 Make a red-brown mix of cadmium yellow pale, scarlet lake and a touch of ultramarine blue. In the same well, add a little more ultramarine blue in one corner; which, when mixed with the red-brown, will make a darker brown shade.

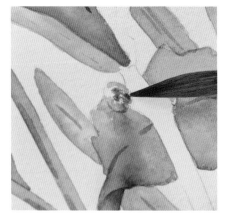

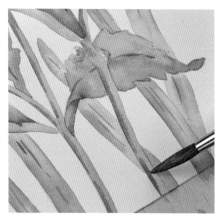

47 Use these two mixes to paint the brown ends where the lilies have withered on the stem.

48 Paint the day lily stems using the warm yellow-green mix of ultramarine blue and cadmium yellow pale, reinforcing it with a stronger mix of the same colour.

49 Change to the size 4 nylon brush, and paint the body of the butterfly with the red-brown mix (see step 46). When dry, apply the deeper brown along the lower edge of the body.

50 Prepare a deep grey-blue mix of Winsor blue (green shade) and scarlet lake, then create a second well of a more dilute version of the same mix. Add the wings, painting the outline with the deep blue. Use the same colour to add shading to the butterfly's body. Use the more dilute version to add some extra markings on the butterfly's wings. Once dry, use the deep grey-blue to add a few fine lines.

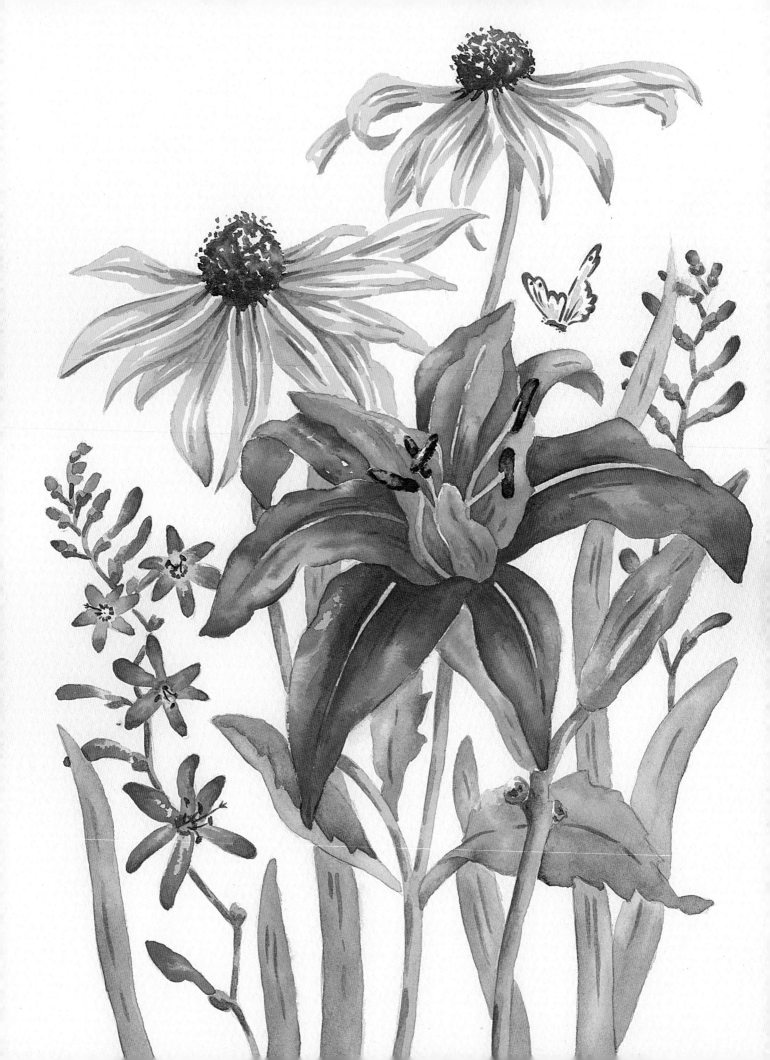

4. CLEMATIS

This trailing group of three clematis blooms created a perfect composition of overlapping star shapes. The shades of mauve depend on the positioning of the flowerheads: the top flower was the palest as it was facing the sun and the lowest one appeared deeper as it was in shadow. The golden centres and the yellow-green foliage complement the varying shades of mauve. This subject uses the negative painting technique to paint leaves on a variegated background.

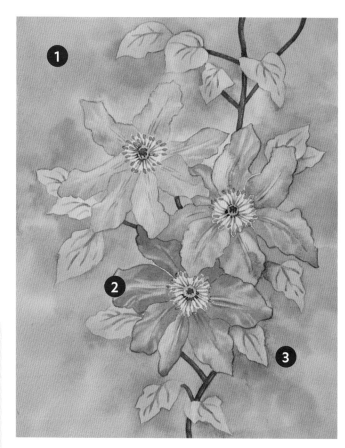

BEFORE YOU START

YOU WILL NEED
Size 6 round brush, size 8 round brush, size 4 nylon brush, outline 4 (see page 101)

COLOURS NEEDED
Opera rose, alizarin crimson, Indian yellow, transparent yellow, aureolin yellow, Winsor blue (green shade), cobalt blue

Technique 1: Variegated wash

This technique produces a mottled effect, which is useful for subtly suggesting the texture of background foliage. I have chosen three shades of green to illustrate the effect this produces.

1 Prepare your colours beforehand to a creamy consistency. Using a medium to large brush, wet the area with clean water, then pick up your first colour and apply it here and there with a loose, dabbing motion. Avoid creating an even coverage; leave gaps.

2 Pick up your second colour and add this wet-in-wet in a similarly loose way. Let the paint flow, applying your brush in different directions to prevent any regular pattern from appearing.

3 Repeat with any further colours, then allow the paint to dry.

Technique 2: Lifting out

The method I am illustrating in this project is a very effective way of producing highlights, which is the lightest area of a form, by means of sweeping a slightly dampened brush through semi-wet paint.

1 Paint the area using any technique you like. While the paint remains wet, dampen a nylon brush a little.

2 Allow the paint to slightly lose its gloss, but not be completely dry, then draw the damp brush through it. The paint will be drawn into the brush, revealing the white of the paper.

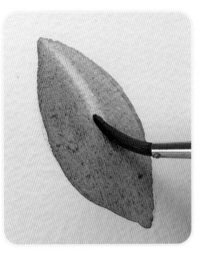

Technique 3: Negative painting

Negative painting is a means of surrounding an object with colour to imply a shape; as opposed to painting the shape directly (positive painting).

When the sunlight catches a leaf, its tone (the lightness or darkness of a colour) often appears lighter than the background foliage. By strengthening the area surrounding the leaf, it will emphasize its lighter shade and throw it forward to give depth and perspective to the painting. The background wash, whether variegated or flat, will form the base tone for a leaf or other object painted with this technique.

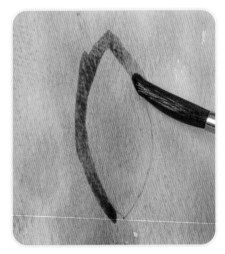
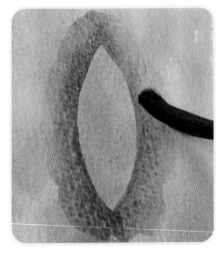
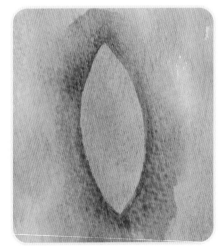

1 With your base wash dry, draw brushstrokes on either side of the leaf shape.

2 Use a clean damp brush to soften the colour away around the shape. Use the gradated wash technique (see page 32) to diffuse the applied colour with water.

3 Continue adding clean water and softening the edges away from the shape, until no hard line is visible.

THE PAINTING

1 Trace the clematis outline onto your watercolour paper. Place your watercolour paper on your board and run strips of masking tape around the edges, covering approximately 5mm (¼in) all round to prevent it buckling.

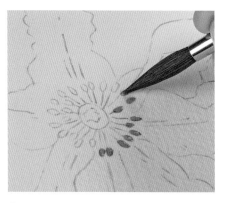

2 Using strong Indian yellow, paint the anthers, using the point of the size 6 brush to apply the paint. While small, the anthers do require short strokes to create the oval shapes; they are not just dots.

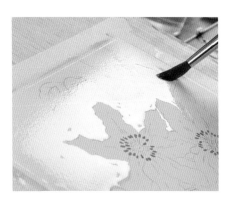

3 Prepare the green mixes, then use the size 10 round to wet the upper part of the background – roughly the top third of the painting. Work carefully around the flowerheads, but take the brush straight over the leaves.

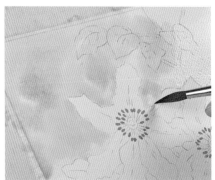

4 Change to the size 8 round and lay in a wash of the warm yellow-green over the wet area, leaving some soft gaps of white so that the wash doesn't appear flat and uniform. Stop short of the flower petals to avoid the risk of accidentally painting over them.

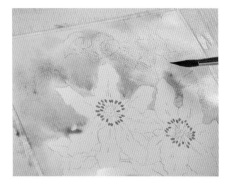

5 Working quickly, add some of the strong warm mix wet-in-wet to create a variegated background. Think about your brushstrokes as you do this; try to hint at quick, simple leaf shapes, as these will add to the illusion of dense foliage behind the flowers.

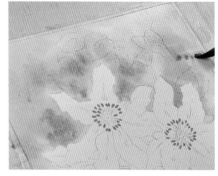

6 Touch in short, dabbing downward strokes of the blue-green mix to further develop the background.

Julie's top tips

Planning Before you begin, plan how you will paint the background. It is too large to paint in one go – the wet base could dry out before you could get all the way round – so you need to work in sections while ensuring there are no visible joins. A stem makes a good dividing line between sections, for example. If a join is obvious, however, it can always be disguised with a leaf painted on top.

Checking wetness When wetting your surface, it may be difficult to see which areas you have covered. If you look at your paper at an angle, you will see the sheen of the paper, and can check that no areas have been left dry.

Green mixes (A) warm yellow-green of transparent yellow and Winsor blue (green shade); (B) strong warm yellow mix of the same two colours; (C) blue-green mix of cobalt blue and transparent yellow.

Wet or dry, but not damp When continuing a background (see step 7), it doesn't matter if the previous area is wet or completely dry; this technique will work with either.

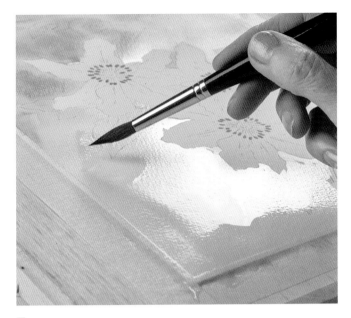

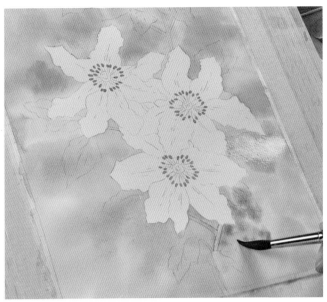

7 Before the section that you have painted dries, wet the next area of background that you want to work. Aim to blend it smoothly with the previous area.

8 Continue repeating the process, building up areas until the background is filled.

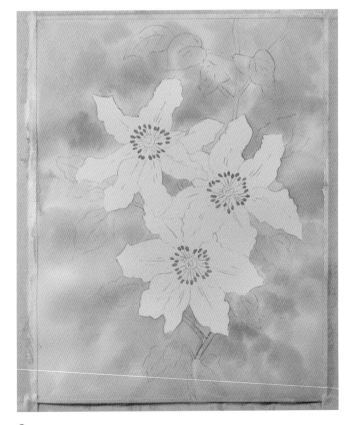

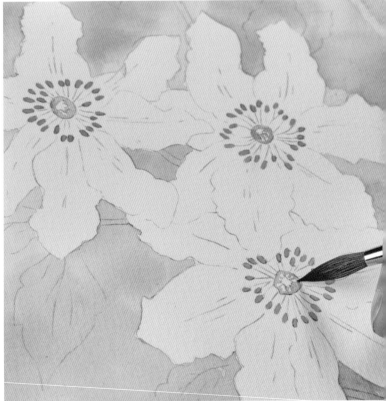

9 Being careful not to touch any wet paint, fill any isolated areas of background, such as the small triangular section near the centre, then allow the background to dry completely.

10 Using the point of the size 6 round brush and the blue-green mix, add the details in the centres of each flower with short brushstrokes. Leave small gaps to suggest the form of the centre.

Julie's top tips

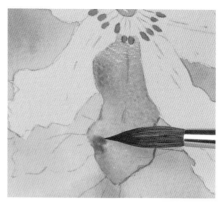

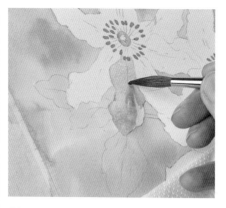

11 Prepare the mixes for the clematis. Starting with the top flower, which is the palest as it is in direct sunlight, begin to paint wet-on-dry with the size 6 round. Touch in the dilute lilac mix, cutting around the anthers carefully.

12 Use the tip of the brush to drop in the dilute purple mix to create a variegated base. Consider the form of the petal as you encourage the paint to move.

Mixes for the clematis petals (A) a strong lilac mix of opera rose and cobalt blue; (B) a strong purple mix of cobalt blue with a hint of opera rose. Make a second version of each, but much more dilute.

Lifting out is a flexible and adaptable technique that relies on having a clean, slightly dampened brush to draw up the colour, and also on how wet the paint is. If the wash is very wet, the surrounding paint will simply flow back into the lifted area. If it is too dry, you will end up with harder edges. Practise on a separate piece of watercolour paper to see how the wetness of the paint affects the result.

Naturalism You will inevitably need to refill and recreate the mixes as the wells run dry. Obsessing about getting the hue uniform misses the natural variance of the petals; in nature, the light will affect the appearance of the colours. Embrace the slight variation that occurs as you re-mix the colours.

Wet-in-wet If you prefer working wet-in-wet, you can glaze the surface of the petals with water and drop in the petal colours (see page 21). When working on a pre-wetted base, the colours need to be mixed to a slightly stronger consistency – they will become more diluted and paler once they touch the surface.

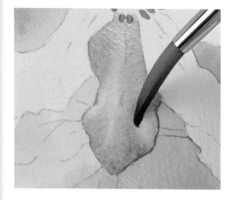

13 Draw a slightly dampened size 4 nylon brush over areas of highlight. The bristles will draw up some of the wet paint and 'lift out' a highlight. Lift out subtle lines by drawing the clean brush from the centre of the petal to the tip, and from the outer edges inwards to suggest the fluted edge of the petals.

14 After you sweep the brush through paint, immediately wipe off excess paint on a piece of kitchen paper. This is a quick way to keep your brush clean and quite dry, which will help you lift out while the paint remains wet.

15 Continue painting the top flowerhead with the two dilute mixes, suggesting shape and form created by the interaction of the two colours and the sweeping highlights created by the lifting out technique. Dropping in the stronger purple mix at the edges of petals helps to create contrast and differentiate them from the neighbouring petals.

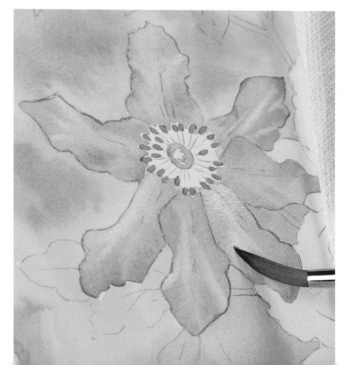

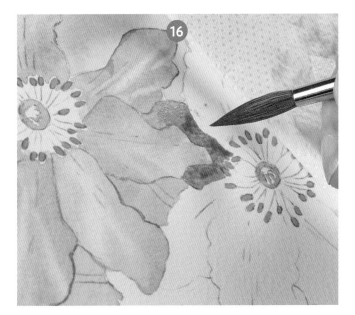

16 With the petals on the first flowerhead complete, move on to the second flowerhead. This one is not in direct sunlight like the first, so use slightly darker, stronger tones. Start with the petal under the first flowerhead, as this will allow you to establish the correct tone.

17 For stronger touches, and simply to add interesting variety, try touching in pure opera rose or cobalt blue. These stronger marks will provide contrast and, because the mixes include the same colours, they will blend in flawlessly with the rest of the palette.

18 Similarly, you can add pure water wet-in-wet to create a larger lighter-toned area. Note that if your brush is too wet when suggesting a highlighted area and the paint surface is too dry, a backrun can occur. Don't worry about this; while it is best to avoid backruns where possible, they can add to the attractiveness of watercolour.

19 Continue working all round the central flower. You can either allow each petal to dry in turn, then move on to the next, or work non-adjacent petals.

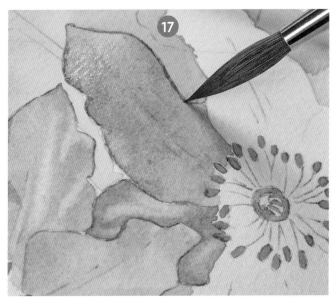

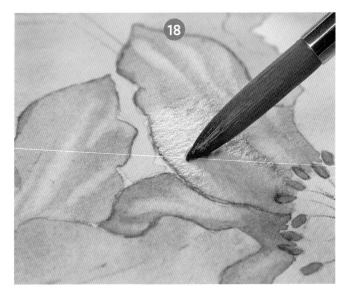

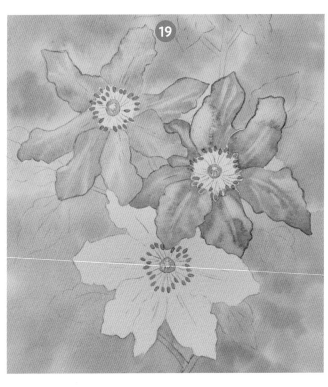

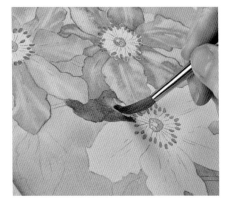

20 Starting with the shaded petal at the top of the lowest flower, use the size 6 round and the stronger mixes of opera rose and cobalt blue and apply with the same method as the other flowers.

21 Add a little aureolin yellow (the complementary) to the strong purple mix to create a greyed version of the colour. Add this wet-in-wet to create a deeper shadow at the top of the petal.

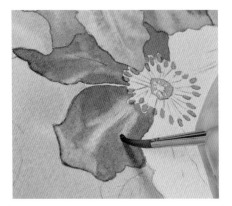

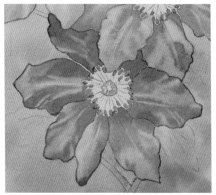

22 Continue to paint the other petals. As the flowerhead is mostly in shadow, the tones will be darker and stronger. Continue using the size 6 round to add the paint, and the size 4 nylon brush to lift out the veins.

23 Working anti-clockwise from the top downwards (clockwise, if you are left-handed), add some of the grey shadow mix (cobalt blue, opera rose and a little aureolin yellow) to reinforce the strength of shadows underneath each of the petals of the middle flowerhead.

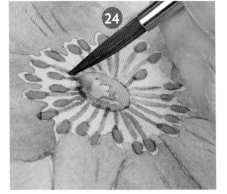

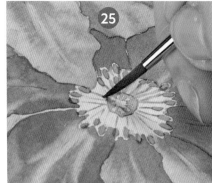

Julie's top tips

Working order If you want to work on adjacent petals that have not quite dried, simply leave a fine gap between the petals. As long as even a sliver of dry paper is left between the areas, you will not run into any problems. Paint the gap once both areas are completely dry.

Mixes for steps 24 and 26 (A) mid-strength lilac mix of opera rose and cobalt blue; (B) mid-strength purple mix of cobalt blue with a hint of opera rose.

Softer shadows To make a deeper, less intense purple for the shadowed areas, add a touch of aureolin yellow to mix B.

Mix for steps 29 and 40 A dark mix of alizarin crimson with cobalt blue.

24 Use the size 4 nylon brush to paint the filaments of the flowers with fine lines of the lilac mix to link the anthers to the centre. Start from the centre in each case, and draw the brush in a short, controlled line to connect with the anther.

25 You can alter the width of the line by changing the pressure you apply. Less pressure will create a finer line.

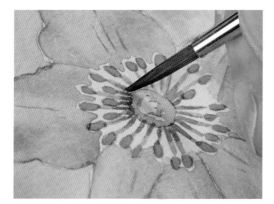

26 With all the filaments in place, add shorter, stronger lines on top to vary the tone and give more strength towards the centre using the mid-strength purple mix.

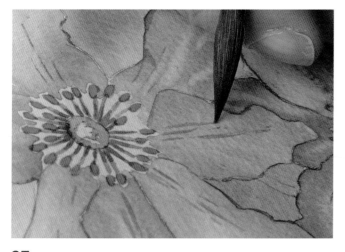

27 You need a brush with a good point for this stage. Continue with a size 4 round, (or size 6 round with a good point) and the mid-strength purple. Use the point to suggest the fine markings on the petals. Use these marking to highlight the central veins and show the characteristic recesses in the centres of the petals of the topmost flower. You should use three lines on each, but break them up.

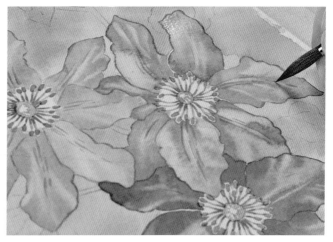

28 Repeat the process for the lower two flowers, increasing the depth of tone for the markings by strengthening the mixes with additional paint. If you have lifted out the central vein on a petal, this stage helps you to emphasize it; frame the light area with the marks you make now.

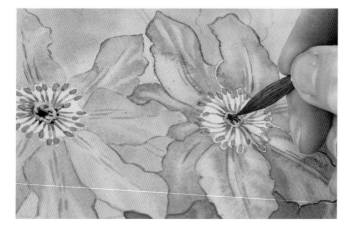

29 Use the dark mix of alizarin crimson with cobalt blue to paint the dark centres of the flowers.

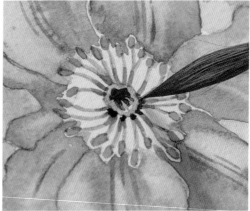

30 Darken the very bases of the filaments (where they join the centre) with touches of this dark mix, in order to emphasize the roundness of the centre. You can use any brush with a good tip – I continued using my size 6 round brush.

Julie's top tips

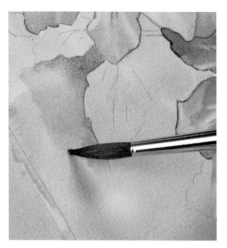

Paint consistency In my experience, a lot of people struggle with negative painting. Getting the consistency right requires practice, but the technique eventually becomes instinctive, and is a very useful skill to develop.

Mixes for the foliage (A) mid-strength warm green mix of transparent yellow and cobalt blue; (B) blue-green mix of cobalt blue with a little transparent yellow.

Turn the board As you paint the background, turn the board to make the last areas easier to get to – there's no need to struggle with awkward brush movements when you can simply move the painting itself.

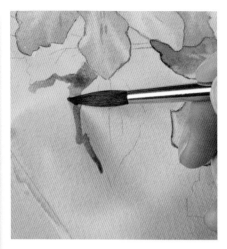

31 Prepare the foliage mixes and use a size 6 or 8 round to surround part of one of the leaves on the outline with the warm green mix.

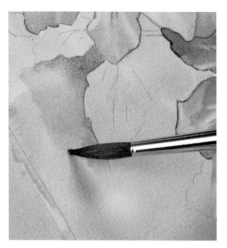

32 Working quickly, dip your brush in water, shake off the excess, and blend the colour away into the background, creating a gradated wash (see page 32 for more on the technique).

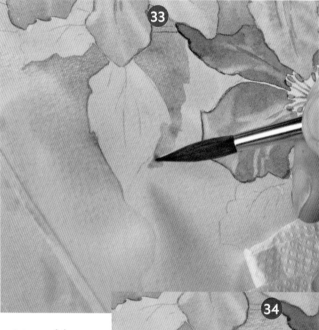

33 Continue working in the same way, applying the paint around the edge of the leaf and blending it away with clean water. As you repeat this, filling in around all the edges of the leaf, the leaf itself will start to come forward through negative painting.

34 Work around the painting to surround the remaining leaf shapes with negative painting. As you draw the paint towards the edge of the paper, use the whole belly of the brush to diffuse, working quickly, in order to avoid any outlines drying.

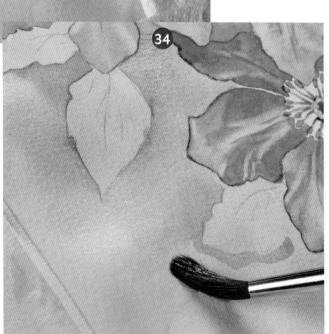

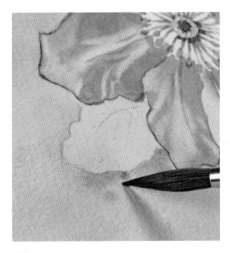

35 While the paint remains damp, add some touches of the blue-green mix for variety and texture, too.

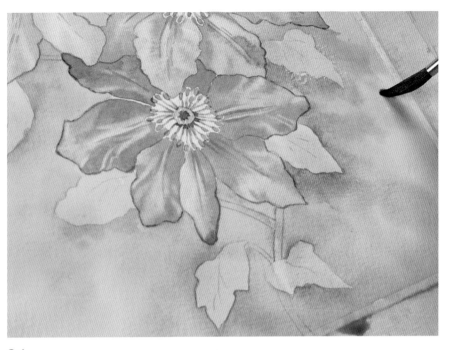

36 Continue working around the painting, varying the strength of the paint by adding more or less water to avoid the result looking too flat, strong or contrived. Work all the way around the painting; turning the board if necessary, so that all the leaf shapes are visible.

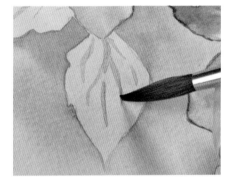

37 Use the point of the size 6 round (or smaller size 4 round) brush to paint the fine veins on the leaves with the warm green mix, using the markings on the outline to help guide you.

38 Where leaves overlap, use the same mixes to add shadows and give a little more form.

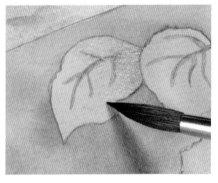

39 While the paint remains wet, soften the colour away with the gradated wash technique.

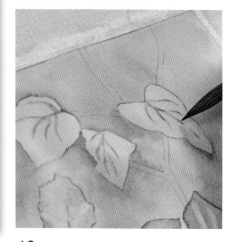

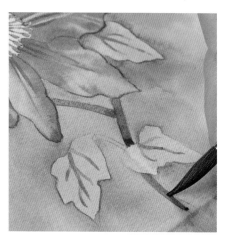

40 Once you have painted all the veins and the shading is dry, vary the tone by overlaying a little of the blue-green mix on the veins here and there.

41 Working section by section, use the size 6 round brush to paint the stems with the warm green mix, wet-on-dry.

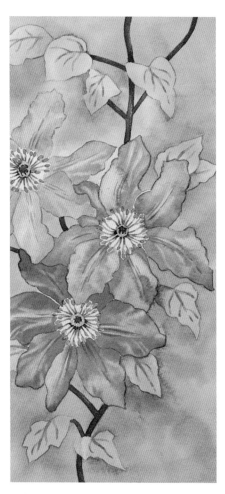

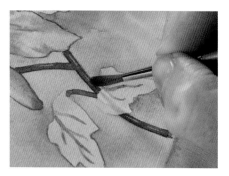

43 Allow the painting to dry, then dampen the size 4 nylon round brush and pinch it to form a flat edge.

44 Use the edge of the shaped size 4 nylon brush to lift out subtle highlights from the stem. Press and sweep to reveal the pale base.

42 While wet, use the size 4 round to vary the tone and add shadow with the dark mix of alizarin crimson with cobalt blue (see page 64).

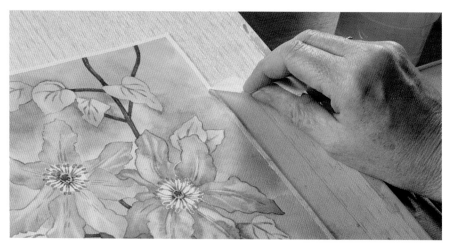

45 Once the painting has dried, carefully remove the masking tape to finish.

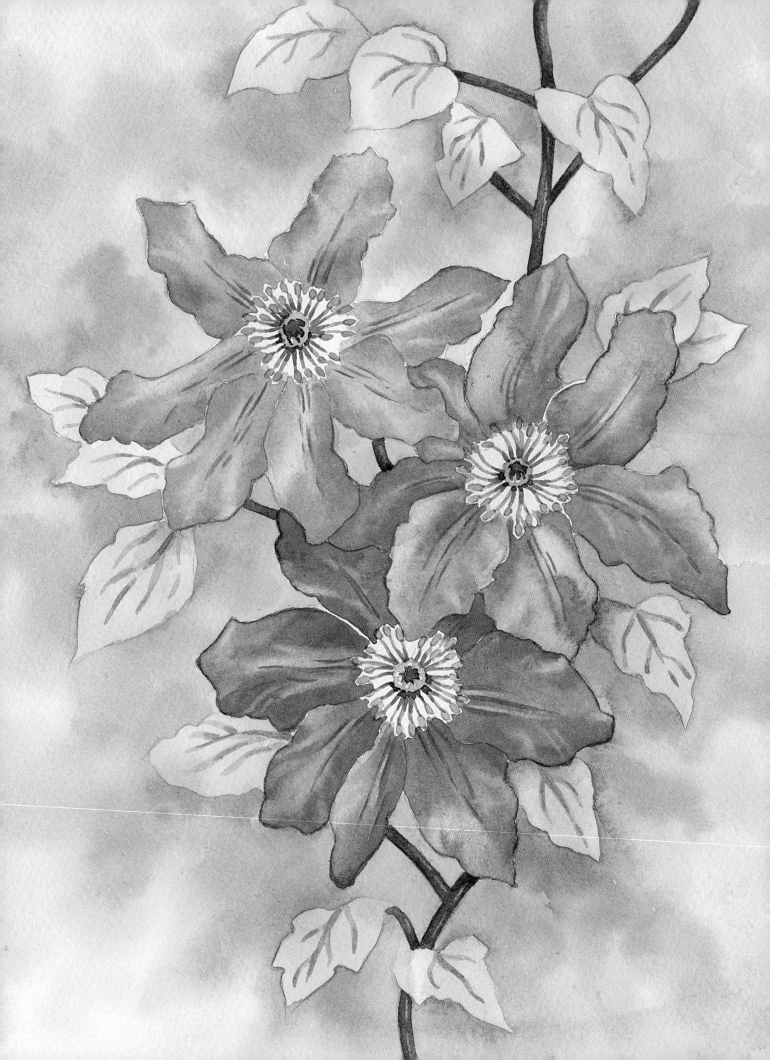

5. SWEET PEA

I can't resist a colourful bunch of sweet peas: I love the clash of pinks with red and purple. Flowers in a vase provide a pleasing composition when placed slightly off-centre on the paper, rather than centrally. It's a tip well worth remembering when painting your own still-life arrangements.

In this painting we will try a vignette background, practise glass painting, and observe and work on the shaping of petals to create their rounded and curling form.

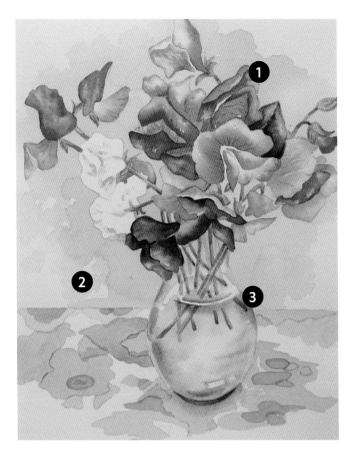

BEFORE YOU START

YOU WILL NEED
Size 6 round brush, size 4 round brush, size 8 round brush, outline 5 (see page 102)

COLOURS NEEDED
Scarlet lake, alizarin crimson, quinacridone magenta, transparent yellow, aureolin yellow, ultramarine blue, cobalt blue

Technique 1: Shaping
The petal shapes are rounded and flowing. It helps to observe the contrasts of tone from one area of the flower to another and create shaping by means of soft variations of tone, directional texture, veinage and highlights.

Sweet peas appear quite varied in shape when viewed from different angles. Here directional texture and tonal variation has helped to create the impression of a soft petal curling towards us.

Technique 2: Vignette background

A vignette background does not extend to the edges of the paper, but fades off to give either a loose, softened edge, or a hard edge.

This is an example of a vignette background, which helps to emphasize the snowdrops' fragility.

In this non-vignetted example, the background wash extends to the outer edge of the paper.

Technique 3: Sharp highlights

To create the illusion of glass – whether it is clear, with grey shades, or coloured (as in this project) – leave areas of bright white paper showing through to suggest the lightest area. In this project I have carefully painted around the highlights, keeping the light area dry.

An alternative method is to apply masking fluid, which is a latex-based product which dries, enabling you to paint over the top of it. When thoroughly dry it can be peeled off to reveal the white paper beneath. Masking fluid is also ideal for fine areas which are too tiny and complex to paint around, such as stamens illustrated on the right.

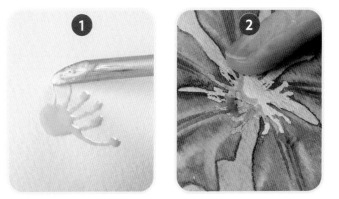

1 You can apply masking fluid with sharpened bamboo (as here), a old fine brush, or even the fine tip of a feather.

2 Once the masking fluid is dry, you can paint as normal over it. The fluid will resist the paint. Once everything is dry, you can gently rub it away with a clean finger, revealing the clean white paper beneath.

Here I have left a white gap to delineate the water's edge, and a highlight to suggest an area catching the light.

Julie's top tips

Where to begin Sweet pea flowers look quite different from one another, so the first challenge is to work out where to begin. Rather than looking for individual petals, look for distinct sections. These might be as small as the curl on the edge, or as large as a whole flowerhead. Similarly, look for groups of colours. Paint all similarly-coloured flowerheads as a group before moving on. This saves you having to continually clean your palette wells and remix colours. You can follow the same arrangement of colours as I have used, or you can swap the colours around.

Mix for step 2
A cool pink mix of quinacridone magenta and cobalt blue.

Creating form Adding paint at the base of a petal section will both suggest shadow cast by the petal above and create the three-dimensional form as the tone diffuses to suggest its curve.

Strenghtening edges Once thoroughly dry, re-wet the area and repeat the process until you are happy with the strength of colour.

THE PAINTING

1 Trace the sweet pea outline onto your watercolour paper. Prop your board at a slight angle and place the watercolour paper on it. There is no need to tape it down. Prepare a mid-strength well of quinacridone magenta, and the cool pink mix.

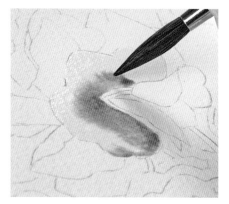

2 Pick a flower to start with, and wet a whole section with clean water using the size 6 round brush. Starting at the lower edge of the petal, drop a little of the quinacridone magenta into the wet surface.

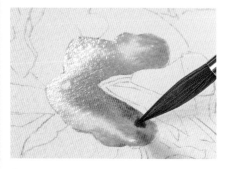

3 Encourage the colour to diffuse in the direction of the petal's growth and gently touch the outer edges so that the paint bleeds inwards, leaving a soft gap to suggest highlights. Reinforce the strength in the shadowed areas by adding more quinacridone magenta.

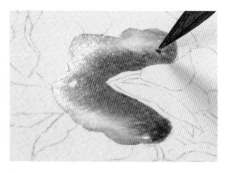

4 Working wet in wet, add a small amount of the cool pink mix to emphasize the shadowed dip and curve of the petal.

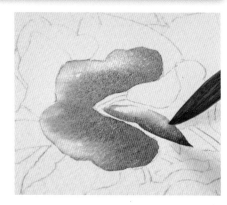

5 Leaving a small gap of clean paper, move on to the next section of the flower and paint it in the same way, paying attention to how you apply the paint to create tone and form.

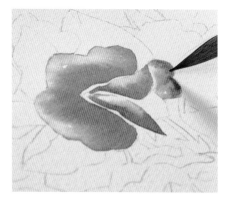

6 When painting the undersides or curled-under areas, pay attention to where you place the stronger tones in order to reinforce the idea of a thin, curled petal.

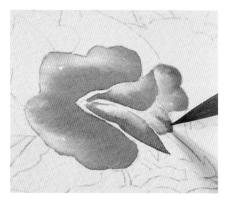

7 Even within one flowerhead, you will find areas that are cooler or warmer. Here, I have added a little more cobalt blue to the mix for the small petal within the centre.

72

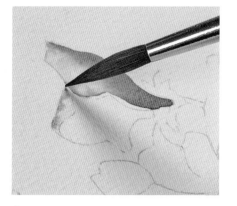

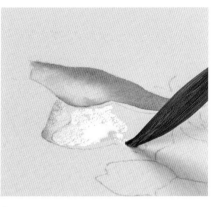

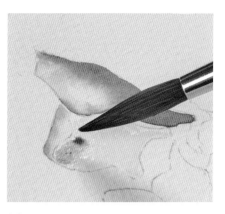

8 Paint the next flower of the same colour. To indicate the petal rolling forward, wet the top edge and gently touch in the paint with a fine brushstroke, allowing the paint to gently fade out to the white paper.

9 When the previous petal is dry, wet the section beneath the rolled edge.

10 Using the same quinacridone magenta, draw the brush along the edge of the rolled petal. This will create the impression of shadow beneath the curl and will contrast more markedly with the light edge, pulling the rolled petal forward.

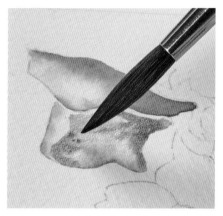

11 Strengthen the tone at the base of the larger section, and draw out a few additional marks and lines with the tip of the brush to give added texture and form.

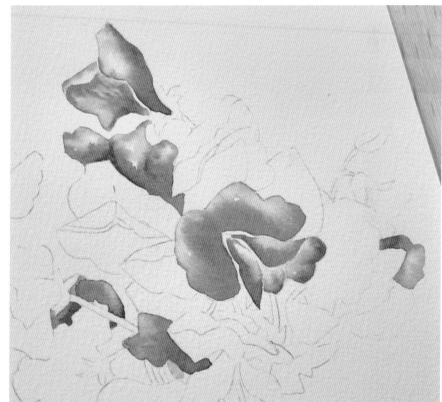

12 Continue painting all the remaining pink flowers. Where a flowerhead sits behind a stem, as here, make sure you use the same strength and placement of colour on both sides to make it clear that it is just one continuous petal. Once you have painted all the sweet pea flowers of a particular colour, consider whether some petals need to be strengthened.

Julie's top tips

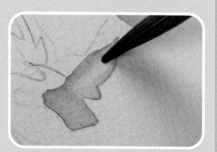

Highlights If a section ends up looking flat, you can add highlights using the lifting out technique (see page 59).

Mixes for the purple flowers (A) cool lilac mix of quinacridone magenta and cobalt blue from earlier, with extra cobalt blue added; (B) Deep blue-mauve mix, made from cobalt blue with just a hint of quinacridone magenta; (C) a burgundy mix of alizarin crimson with a little cobalt blue; (D) a redder glazing mix of cobalt blue and alizarin crimson.

Glazing The beauty of glazing in watercolour is that each successive glaze of colour remains fresh and the white and the reflective surface of the paper will shine through, giving the soft delicacy of the petal. A glaze can be applied to either a wet or a dry surface.

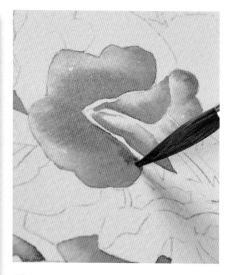

13 Start to strengthen the tone on any flowers you select (see step 11), by re-wetting the whole entire petal.

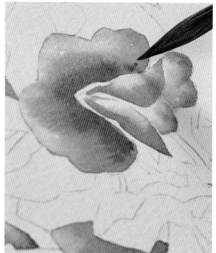

14 While wet, apply the paint in the same way as before.

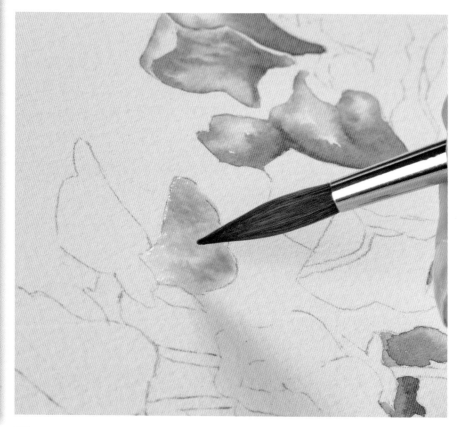

15 Choose the next colour group you want to paint. I have decided to paint the purple flowerheads using the adjusted cool lilac mix. As before, wet the petals and add the adjusted mix first.

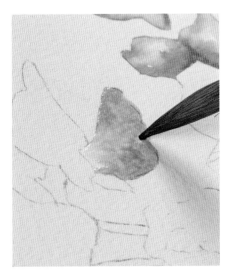

16 While it remains wet, touch in the deeper blue-mauve shade in the shadowed areas.

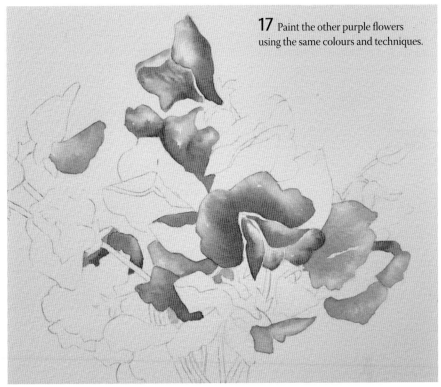

17 Paint the other purple flowers using the same colours and techniques.

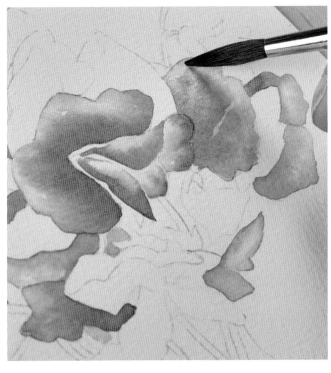

18 For variation, you can glaze (see page 33) some of the purple flowers with the redder glazing mix. This creates visual interest, by adding depth and life. When glazing colour on top of a painted petal, make sure it is thoroughly dry before re-wetting or applying direct colour to avoid the base becoming streaky.

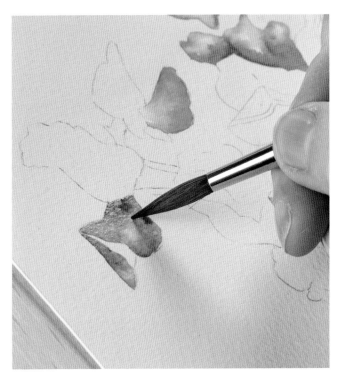

19 Paint the flowerhead on the left-hand side using the burgundy mix, touching in the deep blue-mauve mix for shading and variation. If you find it easier, switch to a small size 4 round brush for tight areas like this one.

Julie's top tips

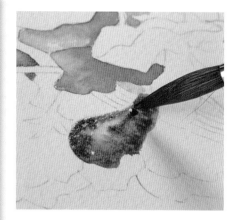

Unwanted gaps You may find occasional small gaps of clean white paper appear as you drop in the colour, as these may have been missed when the paper was given the initial glaze of water. You may wish to leave them in place as highlights and detail. If you don't like them, or they are in the wrong place, you can simply paint straight over them.

Adding veins There are no markings on the outline, but as long as each vein is fine and runs from the flower centre to the outside edge of the petal, they can be added almost anywhere. Equally, if you like the painting as it stands, there is no need to add them.

Mixes for the dark flowers (A) a burgundy mix of alizarin crimson with a little cobalt blue; (B) a dark mix of ultramarine blue with a little alizarin crimson and a little aureolin yellow.

20 Prepare the mixes for the dark flowers. Rinse your brush very thoroughly after preparing these mixes. Start to paint the dark flowerheads as before, using the burgundy mix and add the dark mix to give shape and shading.

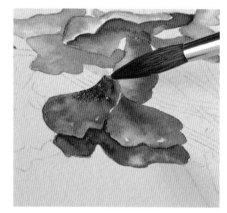

21 Once dry, decide if you want to reinforce the darkness; if so, glaze the relevant parts with a more dilute version of the dark mix. If necessary, add the strong mix while the paint remains damp for added strength of tone.

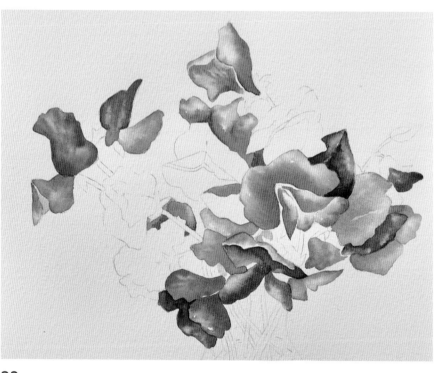

22 Paint the remaining dark flowerheads in the same way.

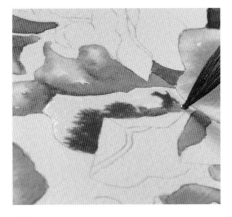 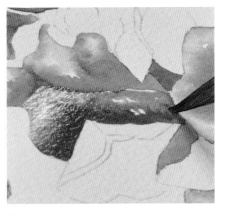 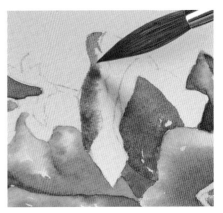

23 Next are the red flowerheads. Prepare the following wells: a mid-strength well of scarlet lake, and a creamier one of quinacridone magenta. Start by adding the scarlet lake to a section wetted with clean water – remember to add the colour at the base of the petal area – and let the colour diffuse upwards.

24 Tease the colour into the rounded wet base of the petal, and add more scarlet lake at the base to strengthen the tone, followed by quinacridone magenta wet-in-wet.

25 Continue painting the remaining red flowers. You can also vary the effect by reversing the colour you use – i.e. adding the quinacridone magenta first, then adding the red.

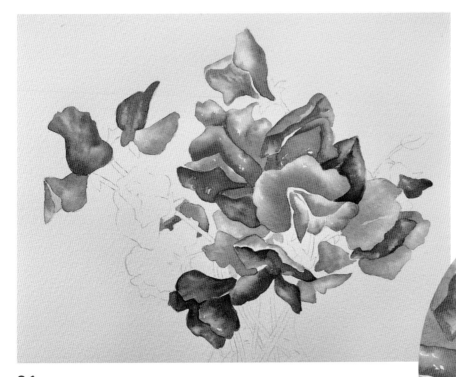

26 Once you have finished the red flowers, allow the painting to dry completely.

27 Use a size 4 round brush to add some fine veining and details to the painted flowerheads to help describe the form; particularly on curled petals. Use slightly stronger mixes of the appropriate colour mix for these details. If you have spare paint left in your palette, you can use that.

Julie's top tips

Tonal balance Touches of a deeper tone of green are needed in the stems to balance with the strength of tone in the flowerheads.

Mixes for the stems (A) a yellow-green mix of aureolin yellow with a little ultramarine blue; (B) a blue-green mix of ultramarine blue with a little aureolin yellow.

Stems in water To help create the illusion of water, observe the source material carefully – you'll notice here that some of the stems are distorted slightly by the refraction through the water surface.

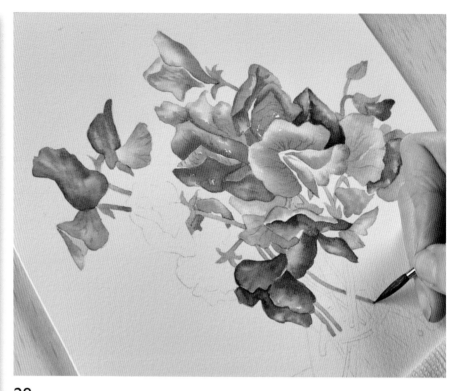

28 Prepare your stem mixes. Working section by section, paint the stems and sepals with the yellow-green mix, applying the paint with the size 4 round.

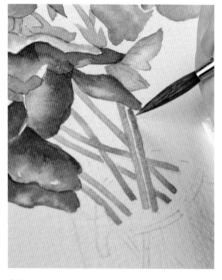

29 As you come to the complex arrangement of stems that are above the waterline, work particularly carefully and leave gaps where they pass behind one another. Be careful not to paint the area reserved for the reflection.

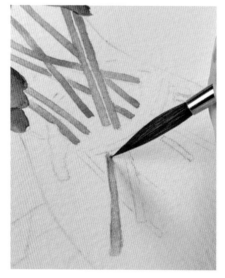

30 The lower section of the stem below the waterline is painted in the same way. Make sure that you paint up to the edge of the waterline, which needs to be left as dry white paper.

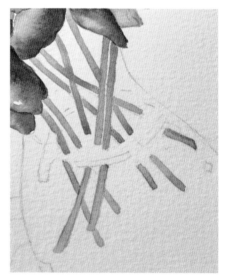

31 Continue painting the remainder of the stems with the same mixes.

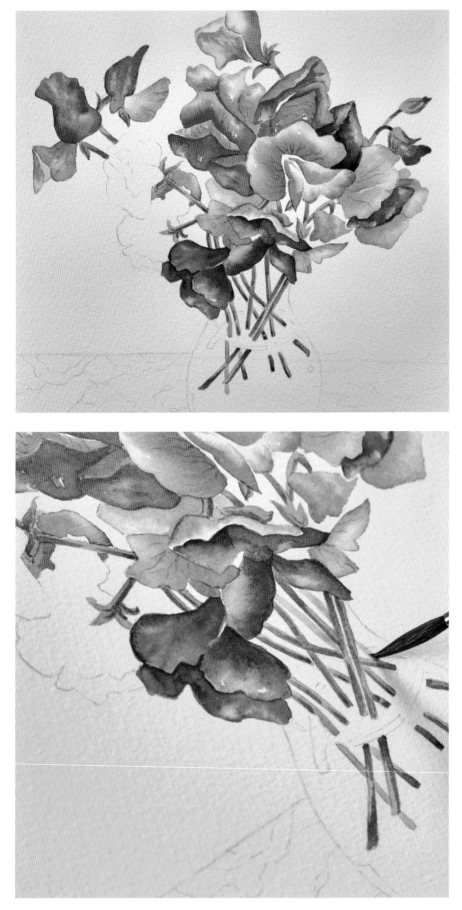

32 Add a little shadow on the stems using the deeper blue-green. Use direct brushstrokes, and avoid painting a continuous line, which will create an unnatural feel. Apply a broader brushstroke of colour where a petal overlaps a stem, to represent the cast shadow.

33 Working freehand, add a few extra stems with dilute shades of green to suggest slightly out-of-focus stems behind the foreground ones.

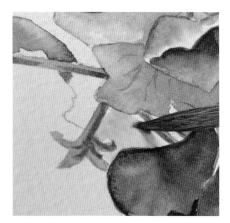

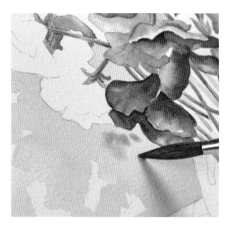

34 Prepare the paints for the background. Starting with the gaps between the flowers, begin to paint the background with the dilute quinacridone magenta, cutting around the flowers and stems. Keep a size 4 for the finer areas and a size 6 for the rest of the background.

35 For the unbounded areas, soften the colour away towards the edges of the paper. As the colour runs out, aim to echo the shape of the flowers in the background, giving a loose vignetted effect.

36 Touch in a little of the purple mix wet-in-wet near the flowers, to suggest more sweet pea blooms in the background.

Julie's top tips

The background Don't worry if the colour runs out completely as you blend the colour away towards the edges. The aim is to paint a background that ensures the flowers remain the focus.

Mixes for the background (A) very dilute quinacridone magenta; (B) a dilute well of a purple mix, made from quinacridone magenta and cobalt blue.

The tablecloth All of the colours here go well together, so don't worry if parts of the pattern overlap; this adds to the impression. Similarly, don't feel constrained by the outline – it's fine to add sections of colour freehand, or to leave them out. If you try repainting this composition, you might prefer the simplicity of a plain tablecloth; in which case, simply paint the area with a flat wash. The important thing is that the colours complement the sweet pea flowers, rather than distracting from them.

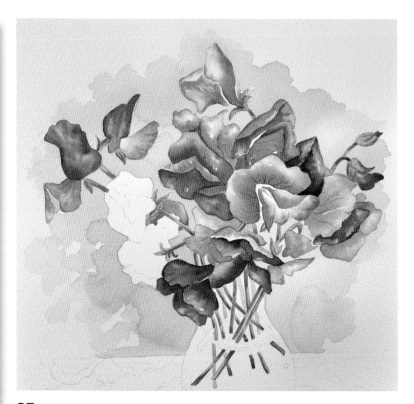

37 Working in sections (see page 66), build up the whole background in this way. You can always use a larger size 8 brush to paint the background providing it has a good point to paint around and between the petals.

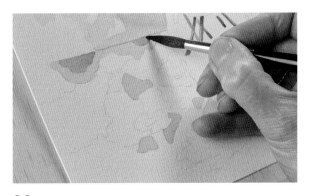

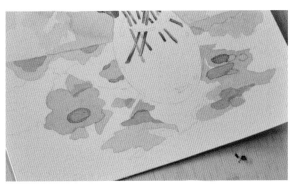

38 Begin to paint the tablecloth. Start with the yellow areas, which are painted with a pale, dilute mix of transparent yellow with a hint of scarlet lake to warm it. Working wet-on-dry, use a size 6 brush to apply the paint. Where appropriate, work up to the edge of the glass vase, but not over it. Once dry, use a slightly less dilute version of the mix to overlay in places.

39 Paint the pink areas in the same way, laying in a dilute wash of quinacridone magenta, then overlaying a stronger wash of the same colour in places once the first layer has dried.

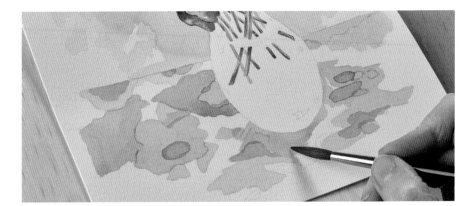

40 Use the yellow-green mix of aureolin yellow and ultramarine blue (the same as used earlier for the stems) to paint a few more shapes on the tablecloth. Leave some areas as clean white paper.

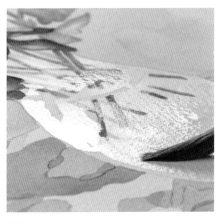

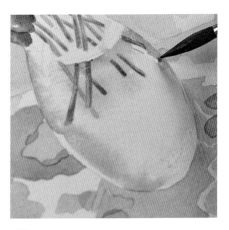

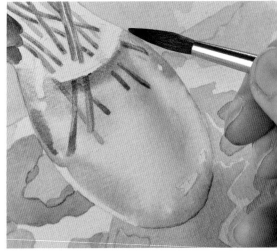

41 Prepare the following additional wells: mid-strength ultramarine blue; dilute quinacridone magenta. Still using the size 6 brush, wet the inside of the vase with clean water, avoiding the areas reserved for highlights. Note that you can work over the stems.

42 Starting at the edge as shown, touch in a little ultramarine blue, allowing it to bleed into the wet surface in the direction of the curve of the vase. Treat the waterline as an edge; sweep the brush along this edge so that the paint runs downwards.

43 While it remains wet, strengthen the blue in parts – particularly near the edges and at the base, to suggest the thickness of the glass – with more of the same colour. Use the brushstrokes to suggest the curvature of the glass.

Julie's top tips

Sharp highlights Using a strong blue when painting the water's surface will give greater contrast with the clean white of the highlight. Work carefully here; it is an eye-catching detail that suggests a sparkle of light.

Mixes for the white flowers (A) a dilute grey mix of alizarin crimson, cobalt blue and a hint of aureolin yellow; (B) a very dilute yellow-green mix of aureolin yellow with cobalt blue.

White flowers When painting white flowers I often paint the background surrounding them first, as this gives an edge of colour to the flower. This helps in judging just how much shadow is required in the flowerhead.

• A white flower can lose its brilliance if too much shadow is painted.

• Aim to leave plenty of white paper.

• As with highlighted areas, the stronger the shade of colour surrounding, the brighter the white will appear in contrast.

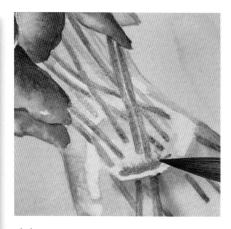

44 Use dilute ultramarine blue to hint at colour around the stems above the waterline, and on the top surface of the water itself, strengthening the colour at the waterline wet-in-wet.

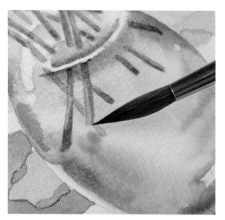

45 Re-wet the interior of the vase below the waterline, and use a few of the mixes used on the tablecloth to suggest a few distorted shapes through the glass.

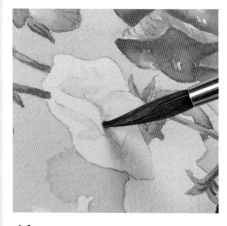

46 Prepare the mixes for the white flowers and use the grey mix to indicate subtle shadows on the white sweet pea flowers. Diffuse the lines away with clean water.

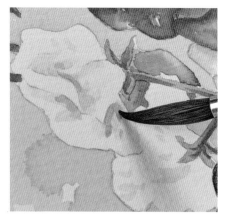

47 Add hints of the dilute yellow-green (aureolin yellow with a little cobalt blue) for deeper recesses. This adds a little naturalism. Add a few more brushstrokes of a stronger grey mix to balance the shade it necessary.

48 Still using the size 6 round brush, use fairly strong ultramarine blue to add a shadow at the base of the vase, then soften it with a sweep of a damp brush. This helps to ground the vase and make the image believable.

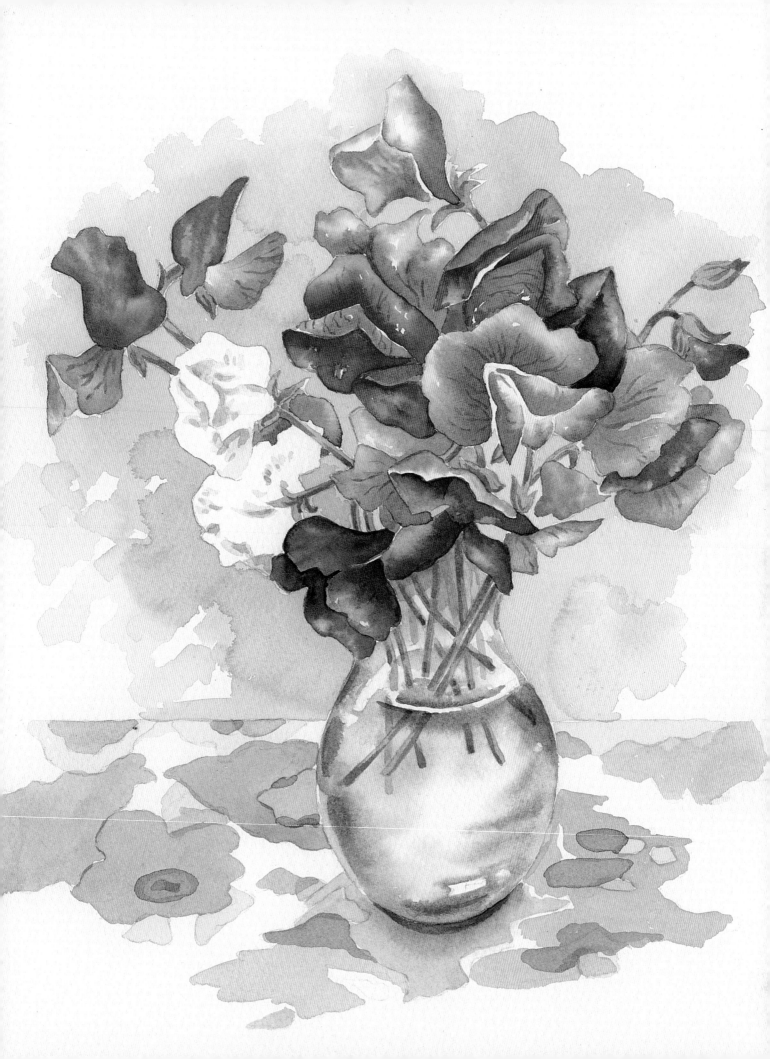

6. WHITE ROSE

I adore white flowers, especially white roses. They are pure, bright and elegant. It was a hot, sunny day when these stunning roses caught my eye. The sun was shining brightly, bleaching out the detail on the petals. The form of the flowers was suggested by the striking pattern of cast shadows.

This painting brings in most of the techniques we have covered in the book. There is more scope to practise painting larger white flowers than in the sweet pea project; an opportunity for a more complex negative approach to leaf painting than we covered in the clematis project; and we also revisit gradated background washes, overlapping and positive leaf shapes and introduce the salt technique to give variety and texture.

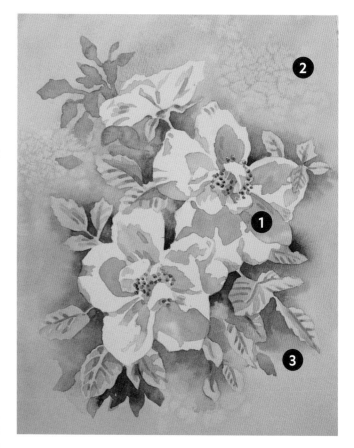

BEFORE YOU START

YOU WILL NEED

Size 6 round brush, size 4 round brush, size 10 round brush, outline 6 (see page 103)

COLOURS NEEDED

Permanent rose, Indian yellow, transparent yellow, ultramarine blue, cobalt blue, Winsor blue (green shade)

Technique 1: Shadows on white

When painting white flowers, the white is represented by leaving the white watercolour paper untouched. Its shape is therefore very dependent on the shadows – though you should take care not to overpaint the shadows, or you will lose the bright impression of the white flower.

Shadows can appear either as a blue-grey, pink-grey or mauve-grey. I chose shades of mauve grey here to complement the golden yellow centres of the roses (see complementary colours on page 16).

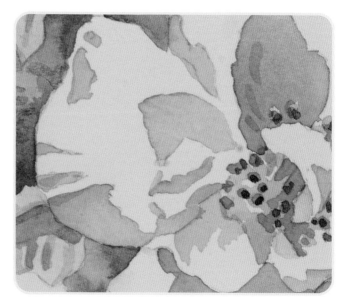

This detail of the white rose showing simplified shadow shapes in tones of mauve-grey and yellow.

Technique 2: Adding salt to create texture

Salt added to wet paint will draw up some of the liquid, leaving an interesting textural effect once dry. The effect of this technique will vary depending on the type and amount of salt you use, as well as the wetness of the paper. I use small amounts of fine sea salt, but you can use table salt, rock salt or other, more exotic, types of salt. Once tried, I am sure you will love to use this method again to evoke the pattern and texture of a garden.

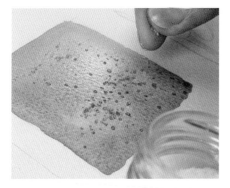

1 Make sure your board is laid flat, then lay in a background wash – you can use any technique for this. Try a flat or variegated wash. Allow the paint to dry a little, so that it is just slightly damp, then sprinkle a few grains of salt into the wet surface.

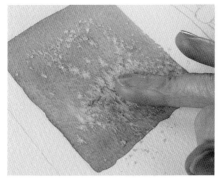

2 Allow the paint to dry completely, then use a dry finger to brush away the salt crystals.

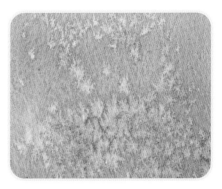

The finished result.

Technique 3: Foliage – positive and negative

This project allows you to further practise the negative painting technique used in *Clematis* (see page 59). Here, the initial background wash forms the base tone to the lighter leaves.

The background in this project is a little more complicated than in *Clematis*, as the rose leaves are more varied in scale and also overlap here and there, creating further shapes in between.

To add a further layer of complexity, I have added positive leaf shapes, by means of a silhouette, to add the impression of more foliage, keeping them as simple shapes so as not to detract from the main foreground leaves.

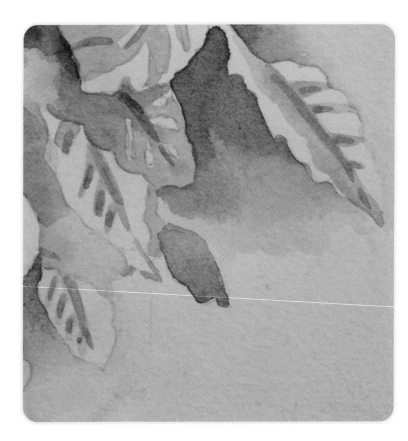

Julie's top tips

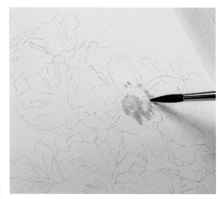

White flowers White flowers benefit from subtlety and a lightness of touch. The background area will define the shape of the flower. To retain a brightness, leave plenty of white paper; avoid overpainting the shadows and adding too much detail. The stronger its tone, the brighter the remaining white paper will appear in contrast.

Green mix
Transparent yellow and cobalt blue.

Background If the paint pools near the white petal when adding the wash, tip the board a little and encourage the paint to flow away. Don't let it dry in beads, or you will end up with backruns.

Be prepared When painting a background using several colours, make sure your mixes are ready before wetting the background so the paint can be added swiftly to the wet base.

Salt As the paint dries the salt will leave a light texture. Allow the paper to dry naturally: don't be tempted to use a hairdryer or you will spoil the effect as the salt dries too quickly.

Different types of salt It is always worth experimenting with the effect of salt on damp paper – try different types and sizes of grain.

Working around Provided that you do not lean on the drying salt, it is sometimes possible to start painting in another area, and in the flower centre, before the area completely dries.

THE PAINTING

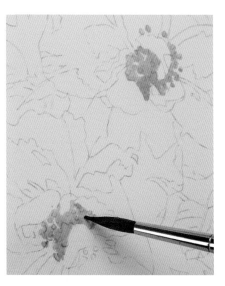

1 Trace the white rose outline onto your watercolour paper. Place the paper on your board and run strips of masking tape around the edges, covering approximately 5mm (¼in) all round. Start by preparing wells of transparent yellow; Indian yellow; and the green mix. Using a size 6 round brush, paint a base wash of transparent yellow on the first rose centre. Use the wet-in-wet stippling technique (see page 45), leaving a few gaps of white paper.

2 Working wet-in-wet, drop in some Indian yellow, and a hint of the green mix, with the point of the brush to give some added warmth.

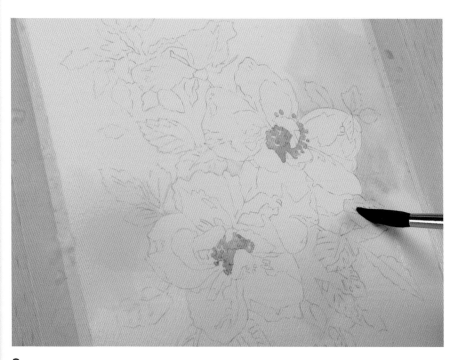

3 To give the white flowers an edge, we need to create a background, leaving the flowers clean. Make large pools of both transparent yellow and Indian yellow, and both cobalt blue and Winsor blue (green shade) – you will need plenty of paint to make sure you don't run out halfway through. Have some salt at the ready, too. Use a size 10 round brush to wet the whole background with fresh water, leaving only the petals of the white roses themselves dry – you can wet over the stems and leaves. Using a size 10 brush, immediately add touches of transparent yellow here and there around the background.

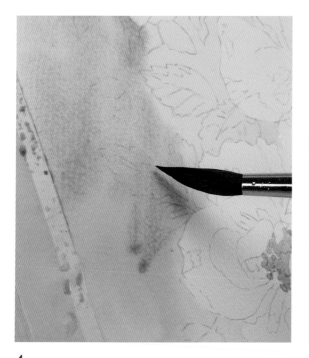

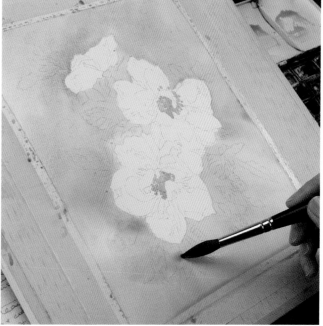

4 Working quickly, add overlapping Indian yellow touches wet-in-wet. Rinse your brush well, and add cobalt blue into some of the empty areas, allowing it to blend into the yellow to create a blue-green. Use the tip of the brush to work carefully around the edge of the rose petals.

5 Add some Winsor blue (green shade) touches, mainly into the blue areas. You are aiming to create a varied background, with some areas of distinct yellow and blue, and areas of a variety of greens where the four colours mix in different proportions.

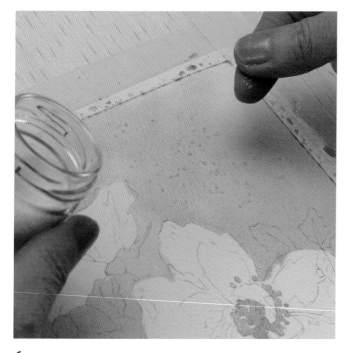

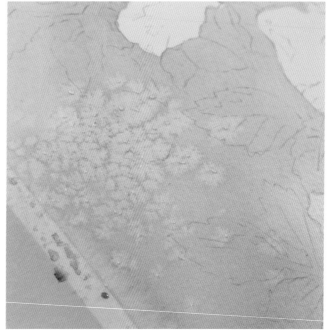

6 While the paper remains damp, sprinkle a few grains of salt on the background here and there.

7 Once the paper is thoroughly dry, brush away any remaining salt grains.

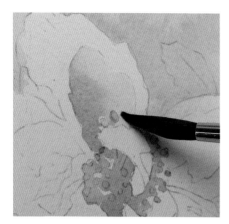

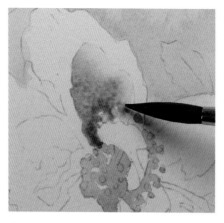

8 Prepare the shadow mixes along with a dilute well of transparent yellow. Using the size 6 round brush, paint the cast shadows with pink-mauve. Work wet-in-dry, varying the tonal strength of the edge. Rinse your brush and diffuse the colour away.

9 While the paint is still wet, quickly drop in the blue-mauve with the tip of the brush. Don't worry if the colour appears too bold; the colour will lighten as it dries.

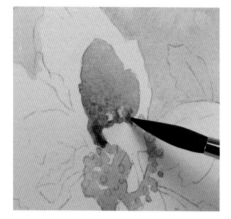

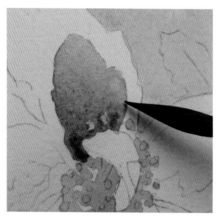

10 Add a touch of the stronger greys towards the centre to strengthen the tone in the recesses and shadowed areas.

11 Add a touch of transparent yellow, very sparingly. This adds a suggestion of light coming through, and avoids the shadow looking matt and flat.

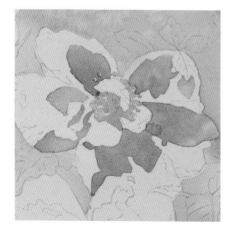

12 Continue building up the larger shadow areas on the first rose. Vary the amount and combination of the shadow mixes to create natural variation.

Julie's top tips

Cast shadow The shadow from an object that is cast onto another surface. When looking at flowers in brilliant sunlight, observe how shadows of the surrounding petals and foliage can be cast on the white petals, creating quite definite shapes.

Mixes for the shadows (A) pink-mauve of permanent rose with a little cobalt blue; (B) blue-mauve mix of the same colours, but with proportionally more blue, plus a tiny touch of transparent yellow; (C) stronger neutral grey of equal parts cobalt blue and permanent rose, with a little transparent yellow added to make the colour less intense.

Tone and contrast The stronger the shadow's tone, the greater the contrast with the white of the petal. This creates impact and a sense of depth, so don't be afraid to build up strong tone in the shadows. White flowers reflect light, so the yellow touches are important to show the effect the centres have on the petals, and to create a sense that sunlight is shining through the petals.

Variegated petals Rather than using a flat wash for the cast shadows, drop in extra colours while wet to form a variegated base and create a subtle glow.

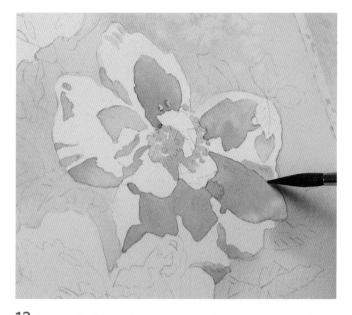

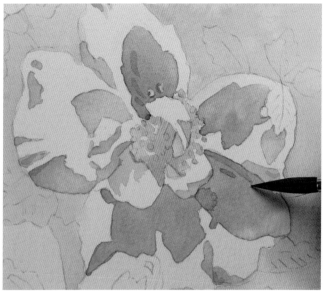

13 Suggest a few folds and creases in the petals by adding some smaller areas of shadow. Because these areas are smaller, you may wish to use just the pink-mauve and blue-mauve mixes, to prevent the colours mixing too much and becoming murky.

14 Very sparingly, add a few wet-on-dry marks with the stronger grey mix to suggest a little more structure to the petals.

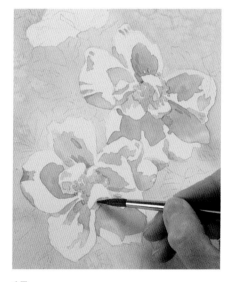

15 Paint the second large rose in the same way. You may need to refresh your mixes.

16 Paint the third rose, at the top, using the same mixes and techniques. Because it is on its side and is not catching the sun in the same way, we don't see many large shadow areas. Instead, use careful wet-on-dry brushstrokes to suggest the shape of the petals.

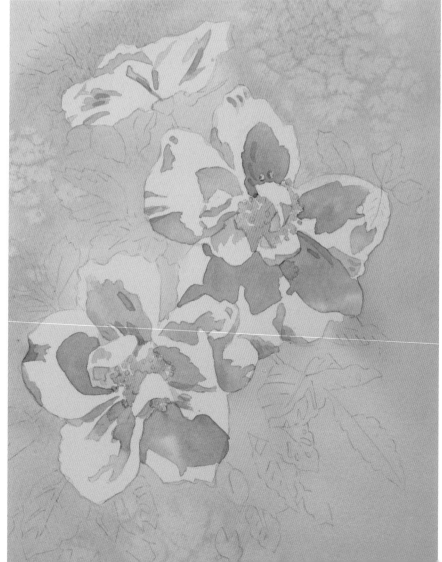

Julie's top tips

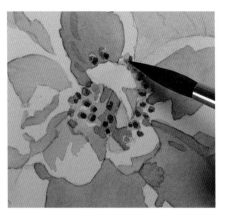

Fine marks If your size 6 brush does not have a fine enough point on it to make the markings on the rose centres with confidence, feel free to change to a smaller brush, such as a size 4 round.

Mixes for the stamens (A) a golden orange mix of Indian yellow with a little permanent rose; (B) a purple mix of permanent rose and cobalt blue. Make this stronger; a creamier consistency.

Green mixes (A) a warm green mix of transparent yellow and cobalt blue; (B) a stronger blue-green mix of transparent yellow and ultramarine blue; (C) a cool dark blue-green of ultramarine blue with a hint of transparent yellow.

Combining techniques The background of this picture is a combination of positive and negative shapes, so we are using techniques from earlier in the book to produce a complex background. Work in a considered way, working some areas wet-in-wet, while allowing some areas to dry and then working over them.

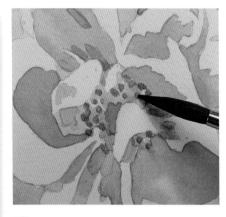

17 The next stage is to strengthen the stamens to finish the flowerheads. Prepare the mixes for the stamens. Using the tip of the size 6 brush, touch the golden orange to the flower centre. Make individual marks for the anthers, and a longer stroke below the curve of the petal to suggest shadow and shape.

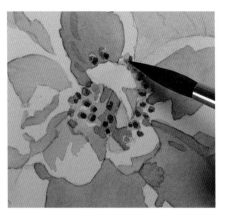

18 Once completely dry, add touches of the strong purple mix; painting occasional anthers with this strong shade, but leaving others orange. Apply the paint as shadowed edges – small curves on the underside of the shapes.

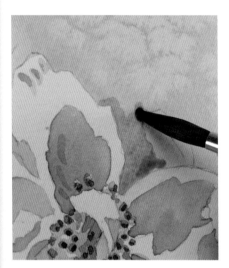

19 Prepare the green mixes. Use the negative painting technique (see page 59) to paint in the background, applying the paint with the size 6 round brush. Load the brush with the warm green mix, and run it around the small leaves on the upper right of the large top flower.

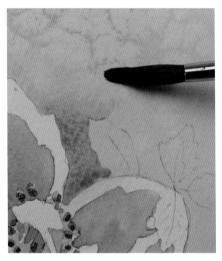

20 Working quickly, diffuse the colour away with clean water.

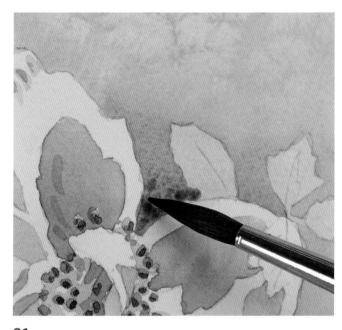

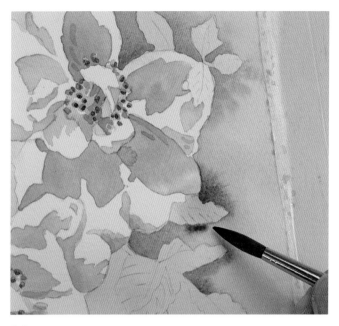

21 Continue in the same way around a few more leaves and touch in the blue-green mix here and there.

22 Working clockwise round the flowerheads, paint in the next section of background with the negative painting technique.

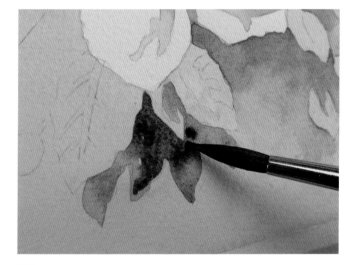

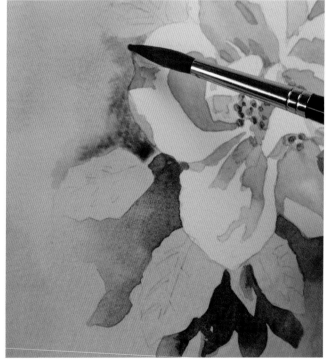

23 Continue working around the flowerhead and leaves, diffusing the colour, followed by painting positive leaf shapes, keeping within the outline, to form a hard edge, rather than soften it. Introduce the very cool dark blue-green by dropping in the colour wet-in-wet and let it flow naturally within the shape. A multilayered effect is created by combining the positive and negative approach.

24 As you work around the background, it is helpful to work in sections between leaves and stems. However, try to achieve a fluid transition between one area through to another. You can always return later to strengthen and balance the tones by re-wetting and glazing more colour on top.

Julie's top tips

Background salt You don't need to worry about disturbing the salt effect when diffusing additional layers of colour on the background; it will show through once the colour dries.

Order of painting I started painting the background surrounding the leaves at the top of the composition, working my way around clockwise. However to avoid leaning on damp paint, I moved my board around. There are no set rules as to where to start. Begin wherever you feel the most comfortable.

Positive leaves Step 27 shows an important stage; it is the only leaf that overlaps the flowers. Painting it with the same colours used in the background wash ensures that it connects with the other parts of the composition.

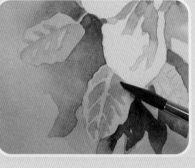

Developing the leaves Working wet-on-dry gives you the control to leave gaps that indicate veins on the surface of the leaves. Note that instead of diffusing the brush-stroked edge with water, I have left a hard edge to link with the style of the petals.

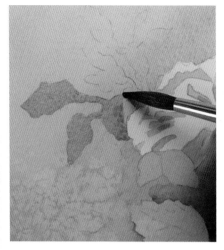

25 As you reach the top left-hand side of the background, paint the positive shapes of the leaves at the top with a silhouetted effect, by diluting the cool dark green and painting a flat wash within the shapes a few at a time. Use the size 6 brush.

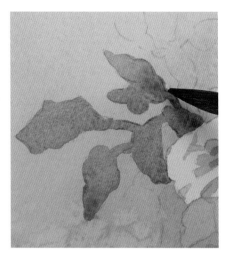

26 While wet, add some of the yellow-green mix in to give a variegated wash.

27 The only leaf which overlaps the flower lies over the rightmost petal of the right-hand flower. To paint it, lay in a dilute variegated wash of the yellow-green and the blue-green. Make sure you paint it with the same colour as the background wash, in order to link it with the base tone of the ones connected to it.

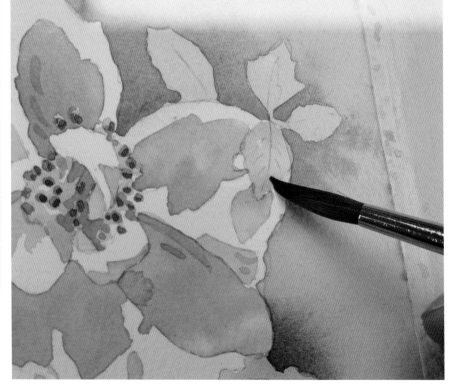

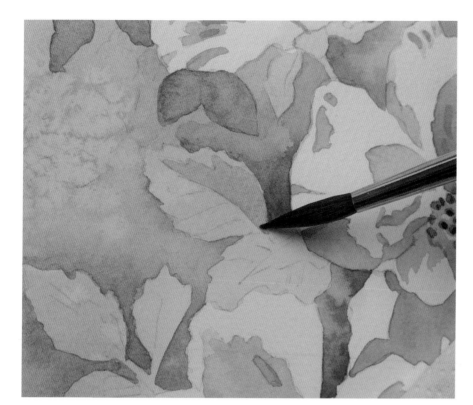

28 Still using the size 6 round brush, and working wet-on-dry, use the blue-green mix to paint the shadow on the first leaf. When viewing leaves in sunlight, one side may appear in shadow and the other side of the main vein in light. For this reason, indicate just a few veins on the light side. Avoid overworking the leaves, or they will become lost in the background shades.

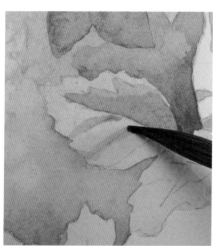

29 Touch in the yellow-green mix to create the suggestion of the veins.

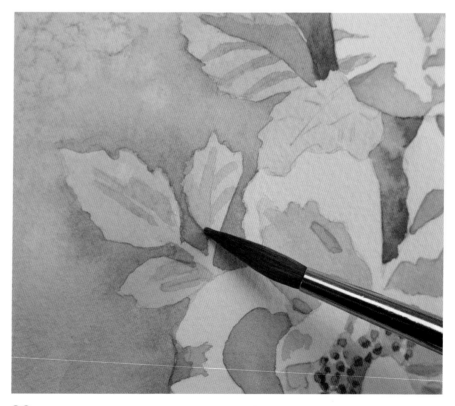

30 Vary the brushstrokes and definition on the other negative leaves. When adding the details, keep them simple, and concentrate on using the green mixes that contrast with those in the background. For example, where the background is blue-green, use the yellow-green to add positive details on the leaves, and vice versa.

Julie's top tips

Variety Avoid a uniform effect as you work round the foliage on the roses: few things in nature appear truly identical, however similar they may be at first glance. Variation creates interest and excitement. This painting has the combination of soft and hard edges. Feel free to add more positive silhouette leaves between the negative shapes to add more density of foliage if you like.

Tonal balance In terms of tone, keep the negative leaf shapes lighter than the background initially – you can always deepen or add detail later.

A light touch You are aiming to create the impression of light on the leaves, and too much heavy brushwork will kill the effect. Overworking the leaves will darken the light tones, with the result that their shapes are lost against the background colour.

Assess your work Step away from your painting once it is finished. Returning a little later with a 'fresh eye' can help you to decide whether more depth of tone is required here and there to balance the painting. Take care not to overwork it!

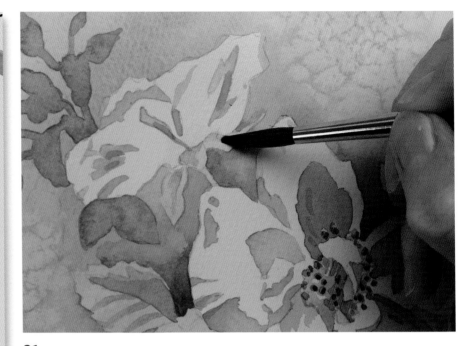

31 Continue working round, building up a varied appearance to the mass of leaves.

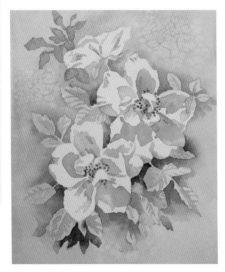

32 Once you have worked round all of the leaves, allow the painting to dry.

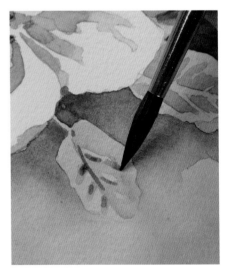

33 Once dry, go back and work wet-on-dry to reinforce the tone and create a sense of form on the leaves. Be minimal with your brushstrokes and keep the veins on the leaves simple.

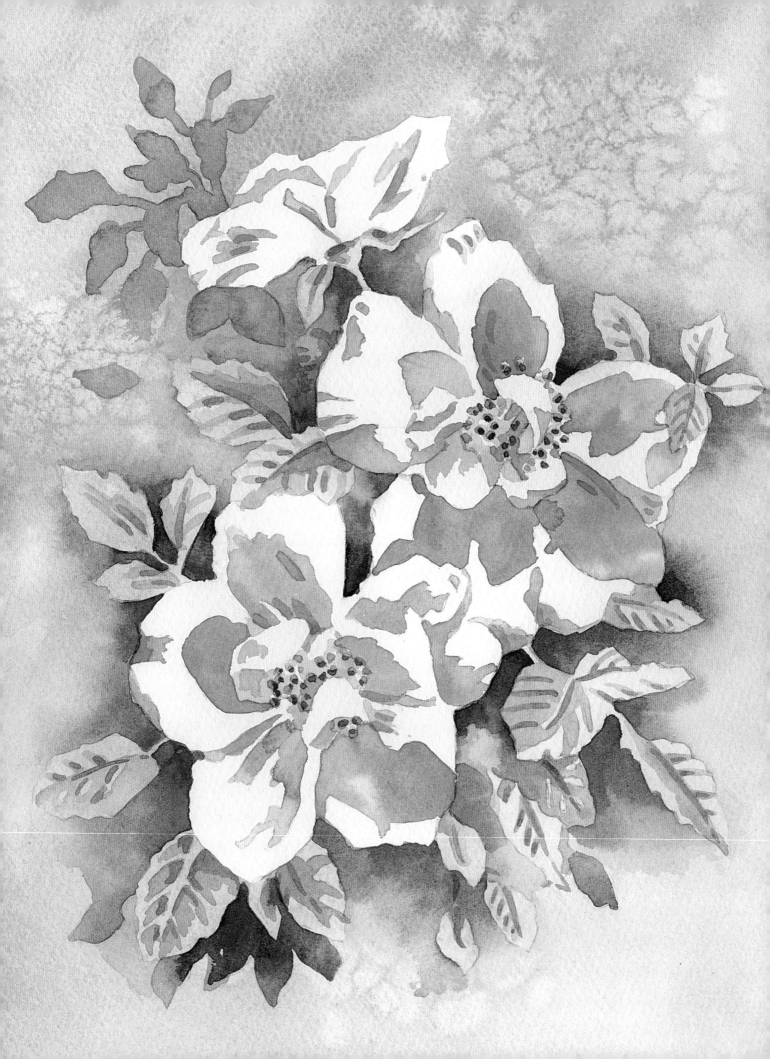

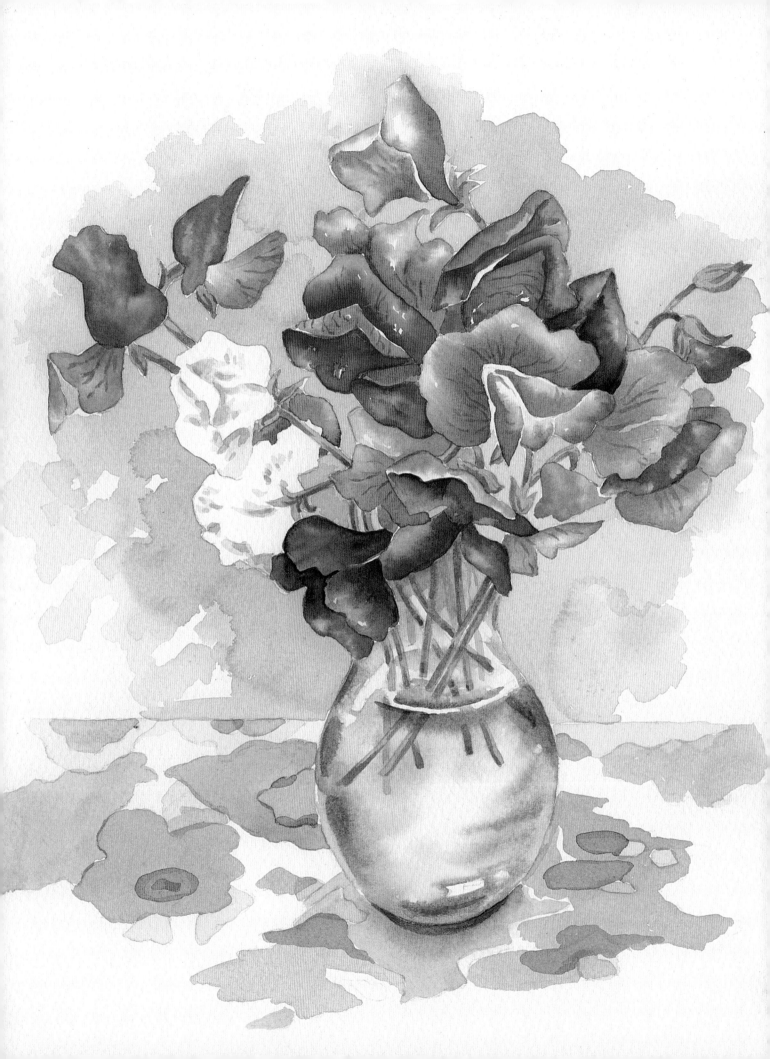

Project 5: *Sweet Pea*, pages 70–83.

THE OUTLINES

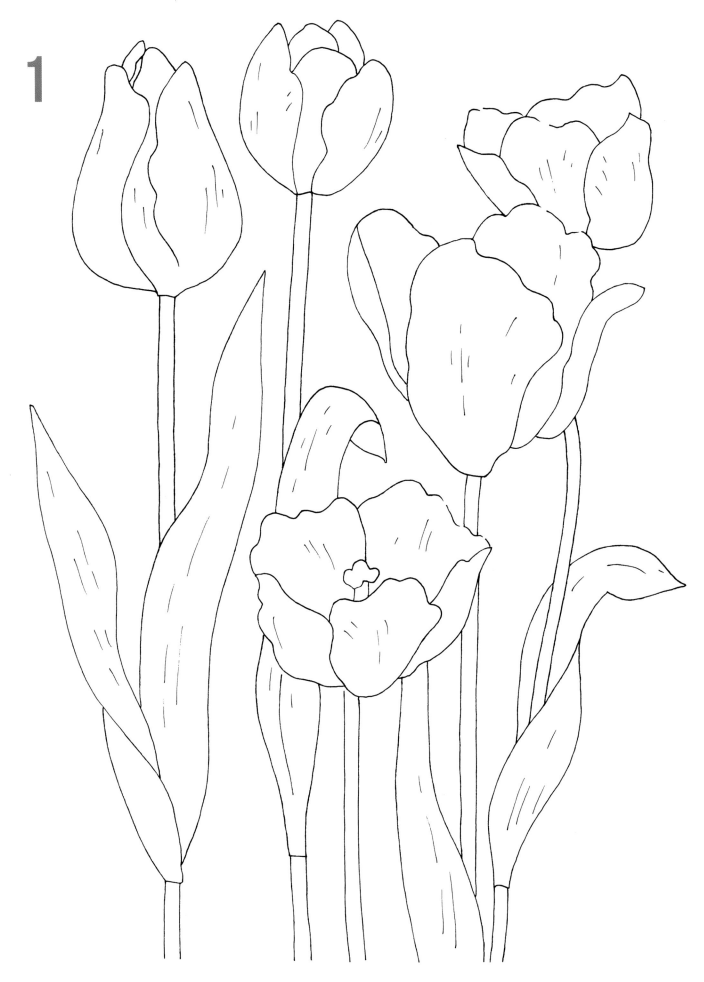

2

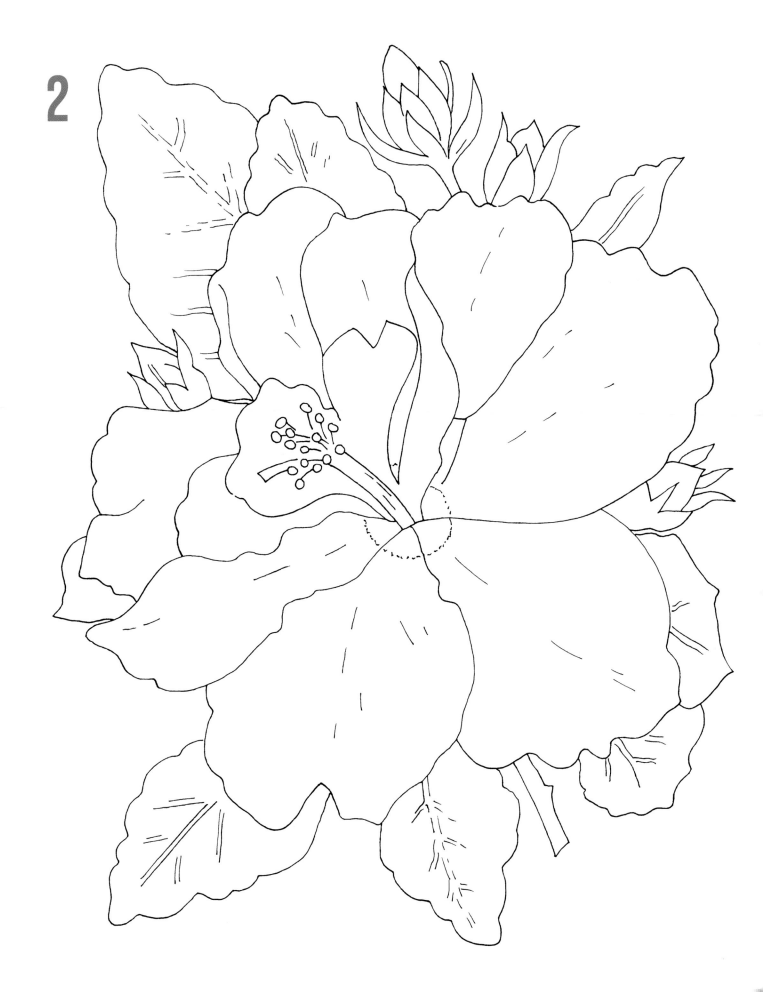

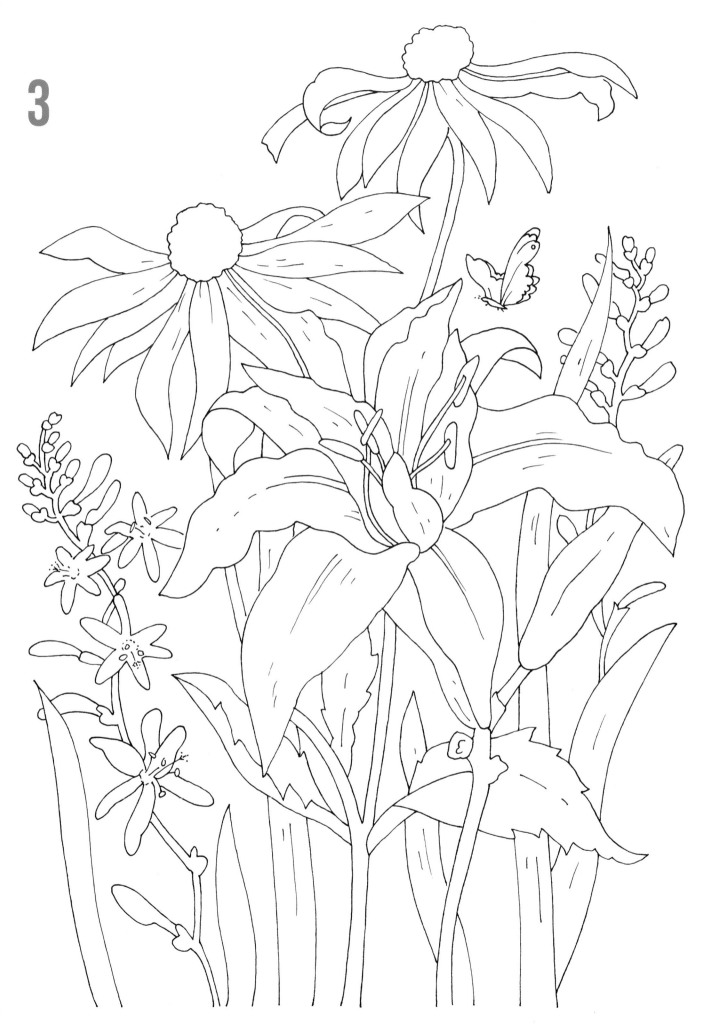

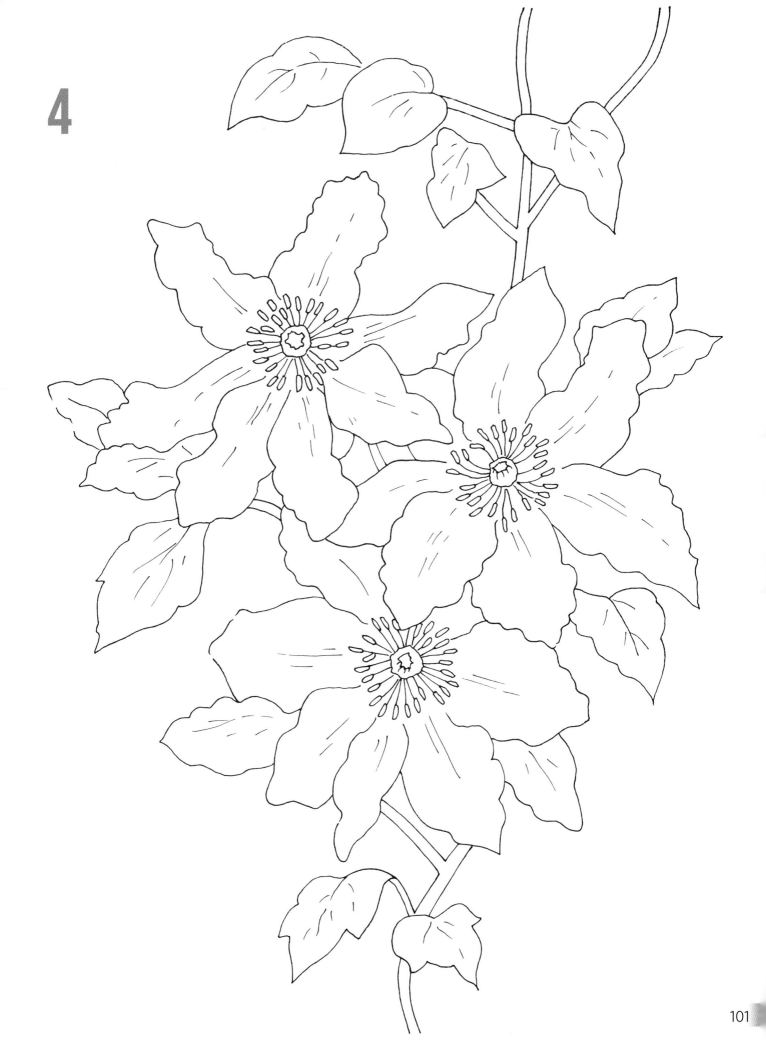

6

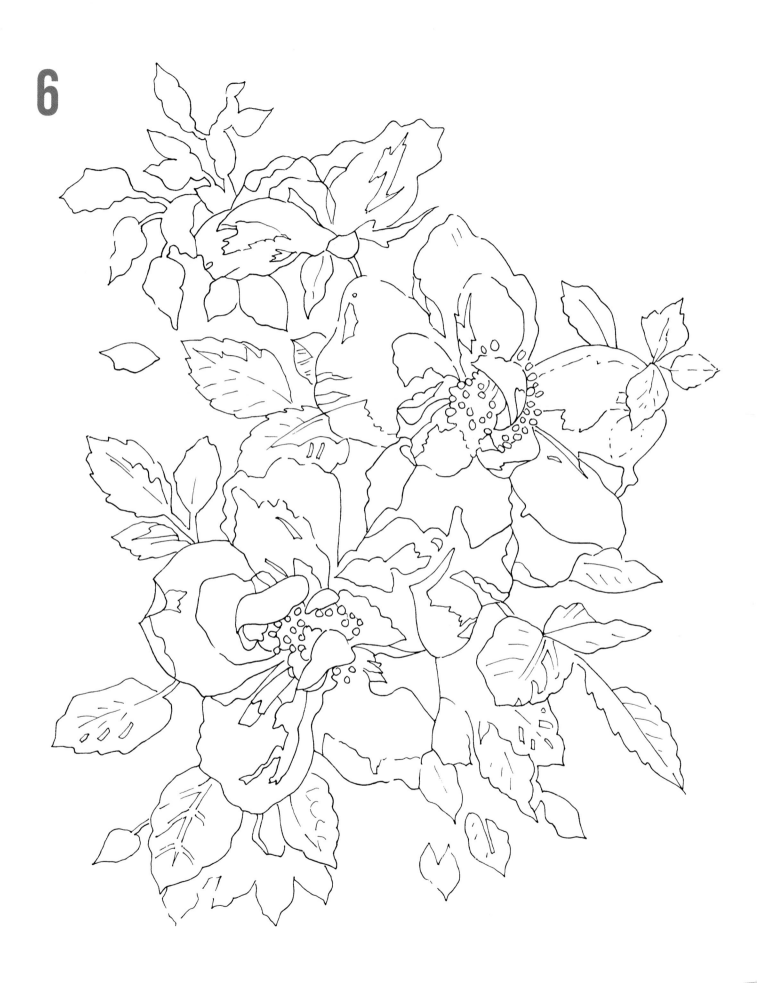

INDEX